LEGENDAR

— OF —

AUGUSTA

GEORGIA

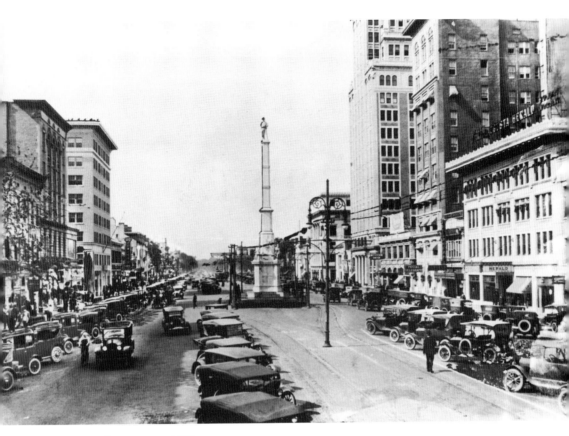

Downtown Augusta, c. 1923
Many people were not so sure that downtown Augusta was going to survive after disastrous fires in 1916 and 1921 burned much of the north and south sides of Broad Street. This photograph is visual testimony to the local legends of Augusta who put their money and faith into rebuilding their downtown, creating the vibrant city that it is today. Seen on the left is the brand-new, eight-story Hotel Richmond, built after the 1921 fire. On the right is the four-story *Augusta Herald* building and the Imperial Theatre, constructed after the 1916 fire. The tall Marion and Lamar buildings, also on the right, were gutted during the 1916 fire and rebuilt. (Courtesy the *Augusta Chronicle*.)

Page one: Gov. Carl Edward Sanders and Carl Edward Sanders Jr.
Former Georgia governor Carl Edward Sanders and his son Carl Edward Sanders Jr. stand in front of the Georgia State Capitol building in Atlanta. (Courtesy the *Augusta Chronicle*, see page 62.)

LEGENDARY LOCALS

OF

AUGUSTA

GEORGIA

DON RHODES

LEGENDARY
LOCALS

Legendary Locals is an imprint of Arcadia Publishing
Charleston, South Carolina

Printed in the United States of America

Library of Congress Control Number: 2013946443

For all general information, please contact Arcadia Publishing:
Telephone 843-853-2070
Fax 843-853-0044
E-mail sales@arcadiapublishing.com
For customer service and orders:
Toll-Free 1-888-313-2665

Visit us on the Internet at www.arcadiapublishing.com

Dedication
To Ollen Columbus Rhodes, Ella Elfreida Sampert Rhodes, and Jean Swann Rhodes, all of whom were very supportive and made my life so much better.

On the Front Cover: Clockwise from top left:
Singer James Brown (Courtesy the *Augusta Chronicle*, see page 71); actress Butterfly McQueen (Courtesy the *Augusta Chronicle*, see page 79); actor Dub Taylor (Courtesy the *Augusta Chronicle*, see page 70); US Army major and *Titanic* victim Archibald Butt (Courtesy the *Augusta Chronicle*, see pages 114–115); philanthropist Emily Tubman (Courtesy the *Augusta Chronicle*, see page 35); cotton gin inventor Eli Whitney (Courtesy the *Augusta Chronicle*, see page 43); evangelist and preacher Rev. Charles Thomas Walker (Courtesy the *Augusta Chronicle*, see page 102); baseball legend Ty Cobb and his family (From the Elna Lomard Collection, courtesy Margaret Holley, see page 11); WJBF-TV *Today in Dixie* entertainment stars, from left to right, Dot Huff, Jimmy "Jim" Nabors, and Flo Carter (Courtesy Flo Carter, see page 75).

On the back cover: From left to right:
Judge Henry Hammond on flooded Broad Street at Eighth Street (Courtesy the *Augusta Chronicle*, see pages 52–53), and funeral home owner R.E. Elliott (Courtesy the *Augusta Chronicle*, see page 39).

CONTENTS

ACKNOWLEDGMENTS

First off, thanks to my life partner, Ervin Edward Smith Jr.; my sisters, Ann, Jan, and Linda; brothers, Larry, Mike, and Doug; and their spouses for their longtime love and support. Thank you also to my current four-legged companions, Willard and Jayme Brown, who have brought such joy into my life.

Thanks go out to the wonderful staff at Arcadia Publishing in Mount Pleasant, South Carolina, especially Katie Kellett, Amy Perryman, Jason Humphrey, Laura Saylor, and Kris McDonagh, for working with me on this second book for Arcadia. My first was Images of America: *Entertainment in Augusta and the CSRA* in 2004.

This book would not be possible without the encouragement and cooperation of Dana T. Atkins, president of the *Augusta Chronicle*, and the talented and professional *Chronicle* photographers who have captured the images of Augusta's local legends.

Thanks also go to the many museums in the Augusta area that preserve the history and contributions of special local individuals, especially the Augusta Museum of History; North Augusta Arts & Heritage Center; Augusta-Richmond County Historical Society; Adamson Library of the Augusta Genealogical Society; Nancy Carson Library in North Augusta; McDuffie Museum in Thomson, Georgia; Aiken County (South Carolina) Historical Museum; Lucy Craft Laney Museum of Black History; and the Georgia archives collections at the Augusta-Richmond County Library on Telfair Street and the Reese Library on the GRU Summerville (formerly Augusta State University) campus on Walton Way.

And thanks, in no particular order, to those who have been so supportive in so many varied ways, including Pat Claiborne; Duncan Wheale; Jeff Barnes; Sherry Fulmer and her Augusta Futurity/National Barrel Horse Association staff; Pete May; Martha Jean McHaney and her HR staff at Morris Communications Company; Billy Morris; Reab Berry and Bill Kirby for their roles in bringing about this book; Linda and Bill Macky; Alan Totten; Flo Carter and her family and late husband, Don; Sharon Jones and her sisters Willia and Dora; Beverly Ford; Luvin and Roger McCoig; Cathy Sprowls and her wonderful late husband, Chuck; Mark Albertin; Sean Moores; and my many friends in the entertainment industry.

Finally, thank you to God and the many friends and extended family members who continue to enrich my life. I'm so blessed.

—Don Rhodes

INTRODUCTION

Over the last 40 years, I have given dozens of talks to civic clubs, senior citizens groups, genealogical gatherings, historic groups, and others about the history of the Augusta area.

And I always loved it when I hear these four words: "I didn't know that."

Any dedicated researcher will tell you that hearing those words means more than any award, especially when educating people who have lived in the area longer than you have. I've always firmly believed that when you educate people about their history, they take more pride in their community and pass on that pride to others outside the region.

When you educate young people about all of the famous and accomplished men and women who come from their area, they are instilled with not only pride but the belief that they can also make something great of their own lives.

I hope this book instills that pride and inspiration in people of all races and all ages. You can, with the right education, internal desire, lucky breaks, and connections, do something better with your lives, whether it is making more money or simply doing something that makes you proud of being you and makes you want to do good for others.

My late mother, Ella Sampert Rhodes, believed in the Methodist hymn, "Others, Lord, yes others. Let this, my motto be. Help me to live for others, so that I might live for thee."

Since Augusta's founding in 1735, two years after British general James Edward Oglethorpe founded Savannah, recorded history shows that the area has been full of the good deeds of philanthropists, business leaders, and religious folks who truly believed they could make Augusta a better place to live and work.

After slavery was abolished, former slaves tried to move beyond that dark period and strove to make life better for their fellow African Americans. Lucy C. Laney, John Hope, and others knew that the way out of poverty and the way to earn community respect and business achievement was through education. People like Rev. Charles T. Walker knew that after the Civil War, hope for all races, and Augusta citizens, had its foundation in compromise, not hatred.

It is no wonder that when the Reverend Walker died in 1924, after his glorious Tabernacle Baptist Church was built, the *Augusta Chronicle* reported on its front page that 10,000 people, black and white, filed past his casket.

Like many cities across the nation, Augusta had turbulent times during which good citizens did very little or nothing to stop evil folks who were greedy for power and money. But in most cases, the good citizens got some guts and took action to make their town better and get rid of the evildoers.

Political leaders of the Cracker Party cast their evil shadow over Augusta for 40 years in the first half of the 20th century. Along with election frauds, they controlled and abused the police and fire departments to get back at political enemies and critics and to solicit money protection payoffs. But they eventually faded into Augusta's history when the main leader, John B. Kennedy, died after his wife shot him five times. She was found not guilty of her actions, thanks to her lawyers, Strom Thurmond, former governor of South Carolina, and Roy V. Harris, former speaker of the Georgia House of Representatives.

Augusta has had a stable amount of citizens, with multiple generations of families calling the area home. These citizens have treasured and preserved the city's history as well as made new history with their own accomplishments. The area has also had a huge transitional population, thanks to the Medical College of Georgia (now Georgia Regents University); military bases Camp Hancock, Camp Gordon, and Fort Gordon; the nuclear energy Savannah River Site; and four-year educational centers Paine College, GRU Summerville (formerly Augusta State University), and University of South Carolina-Aiken.

I hope this book preserves the history that the longtime families already know, and I hope it educates and entertains the newer residents who are eager to learn more about this wonderfully productive and creative area of mostly loving and caring citizens.

There are several songs, good and bad, that mention Augusta. One of my favorites, simply titled *Augusta*, was written by Carey Murdock and recorded for his album *Baby Don't Look Down*. Murdock was born in Augusta and grew up across the Savannah River in North Augusta, South Carolina. He, like many others living on the South Carolina side of the river, understands that the heart of Augusta, especially its downtown area, financially and socially affects those on both sides of the river. The words to Murdock's song (which can be found on YouTube) are as follows:

A southern belle, I crossed you in the moonlight
Turned 'round to find you had not gone
The things I had were all words that you had gave me
The things I'd lost you had retired

Heading downtown I'm going to walk the river
Come from Eighth and turn down Broad
I call up my friends and gather them around me
Visit my old familiar haunts

Some folks I meet they don't have anything to say
* about you*
That I could take home to my ma
But I'm not swayed, Babe, they can speak
* themselves blue*
It doesn't change who you are

You're the one that stands behind me
When the dark thunder clouds roll
You're the place that's always open to welcome me
* back home*
You're a thousand streetlights shining
On all the roads I walk alone
My fair Augusta, my steady queen, my lady luck

If you've got a queen you've got to treat her like one
If you want that queen to shine
The one I've seen standing so proudly on the fall line
She don't want to be outdone

She's a golden lass
With eyes that you can run to
And you can take that to your ma
And if you're ever blue
Maybe you can start to find your way home
And lay down some Georgia roots

And let her . . .
Be the one that stands behind you
When the dark thunder clouds roll
Be the place that's always open to welcome you
* back home*
'Cause there's a thousand streetlights shining
On all the roads you walk alone
She's the name that's always mentioned when our
* story's told*

And she smells of sweet magnolias if my memory holds
Her music is moving through me like the Gospel
* songs of old*
She's standing there behind me as the dark thunder
* clouds roll*
She's a thousand streetlights shining on all the roads
* I walk alone*
And her arms are wide open to welcome me back home
My fair Augusta, my steady queen, my lady luck

CHAPTER ONE

Notable Sports Figures

There is no telling when organized sports originated in the Augusta area, but it is known from early editions of the *Augusta Chronicle* that organized boat-rowing races were held on the Savannah River as early as 1837, with three teams competing and a trophy being awarded.

"Base Ball," as it was then written, was played with organized teams in the late 1800s, but it caught fire when the South Atlantic League (SALLY) was formed in 1903. The Augusta Tourists became one of the original teams in that league, and during its first game in 1904, a young North Georgia boy named Tyrus Raymond Cobb made his professional debut.

In the early 1900s, US presidents came to Augusta to relax and golf at the Augusta Country Club. That sport became popular when a New York financial expert named Clifford Roberts joined with Georgia golfing legend Bobby Jones to transform acres of fruit orchards on Washington Road into one of the most famous golf courses the world has known, the Augusta National Golf Club.

Throughout history, the Augusta area repeatedly furnished the sporting world with some of the greatest athletes ever known, including champion boxers Beau Jack, Vernon Forrest, and Ray Mercer; Olympic track king Forrest "Spec" Towns; football players Emerson Boozer, Charlie Waters, Charley Britt, Herschel Walker, William "Refrigerator" Perry and his brother Michael Dean Perry; and professional golfers Larry Mize (the only Augustan to win the hometown Masters Tournament), Vaughan Taylor, Charles Howell III, Mitzi Edge, and Eileen Stulb. Many, many other Olympians and professional players have called Augusta home.

Augusta's Jennings Stadium on Walton Way was the first in the South to have baseball games played under electric lights. Legendary soul singer James Brown used to climb nearby trees to watch the games when he could not afford to see them from inside the stadium.

Just a few blocks away, the city's Warren Park baseball stadium is across from the cemetery where its namesake, Capt. William Henry Warren, is buried. It was the site of spring training for teams from Boston, New York, Detroit, Philadelphia, and Ontario, and some of the game's greatest players, including major-league manager and outfielder Casey Stengel, practiced there.

Every year, thousands of people from around the world come to Augusta to watch the greatest golfers play, the greatest rowers row, the greatest unknown young basketball players shoot for the hoops, the greatest boat-racers rev up their motors on the Savannah River, and the greatest bicycle riders peddle their two-wheeled machines in fast, precise formations.

The world comes to Augusta to watch the best, because throughout its history, Augusta has always offered the best.

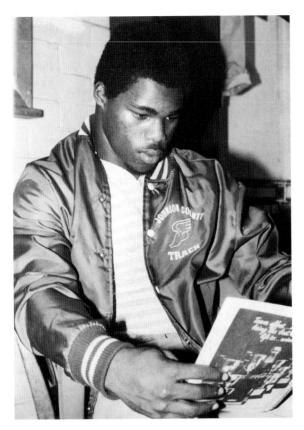

Herschel Walker

Walker, who was born in Augusta and grew up in nearby Wrightsville, Georgia, played 12 seasons for the National Football League with the Dallas Cowboys, Philadelphia Eagles, Minnesota Vikings, and New York Giants. He won the coveted Heisman Memorial Trophy in 1982 while playing for the University of Georgia, where he earned a bachelor of science degree in criminal justice. (Photograph by Rickey Pittman; courtesy the *Augusta Chronicle*.)

Lou Brissie

The first recipient of the North Augusta Sports Hall of Fame's Lou Brissie Award in 2012 was Brissie himself. The World War II hero, who earned two Purple Hearts, is pictured with US president George W. Bush. Brissie is the subject of the book *The Corporal Was a Pitcher: The Courage of Lou Brissie* by Pulitzer Prize–winner Ira Berkow. He played for the Philadelphia Athletics, under manager Connie Mack, and for the Cleveland Indians. (Courtesy the *Augusta Chronicle*.)

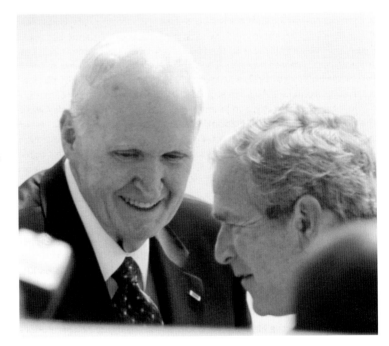

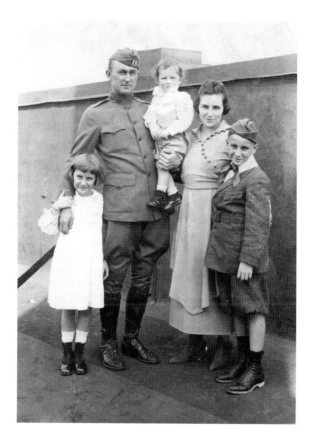

Ty Cobb

This rare photograph of baseball legend Tyrus Raymond Cobb shows him in his World War I uniform with his wife, Charlie, and three of his children. Cobb began playing professional baseball in 1904 with the Augusta Tourists team in the first season of the South Atlantic Baseball League. He joined the Detroit Tigers in 1905 and played with the team until 1926. He played his final two seasons with the Philadelphia Athletics under famed manager Connie Mack. Cobb, as a member of the Athletics, racked up his 4,000th career hit on July 18, 1927, with a double in the first inning while playing against the Detroit Tigers. He married a prominent Augusta woman, Charlie Marion Lombard, in 1908, and four of his five children (Ty Jr., Herschel, Beverly, and Jimmy) were born in Augusta. Shirley was born in Detroit. Cobb became the first inductee into the National Baseball Hall of Fame in 1936. He was one of the first professional athletes to do commercial endorsements, including for a health drink, chewing gum, cigars, whiskey, Coca-Cola, and many others. He was not the first player to have his signature on a Louisville Slugger bat (that was Honus Wagner), but he was the second. He was the first athlete to make a movie, *Somewhere in Georgia*, though it was filmed in New York. Contrary to widespread belief, Cobb had many close friends, including Coca-Cola president Robert Woodruff and Augusta National golf course cofounder Bobby Jones. He loved hunting with bird dogs and playing golf almost as much as he loved baseball. Cobb lived many of his retirement years in California but often returned to his beloved South. He died at Emory University Hospital in Atlanta on July 17, 1961, at the age of 74. Cobb had earlier donated $100,000 to help create a hospital in Royston. It evolved into the Ty Cobb Healthcare System, which today provides medical needs to citizens throughout north Georgia. His will also bequeathed 25 percent of his estate (roughly $2 million in 1961) to an educational fund for needy students he had started eight years before his death. That foundation has awarded more than $14 million in scholarships to thousands of students. More can be read about him in the biography *Ty Cobb: Safe At Home*, written by the author of this book. (Photograph from the Elna Lombard Collection; courtesy Margaret Holley.)

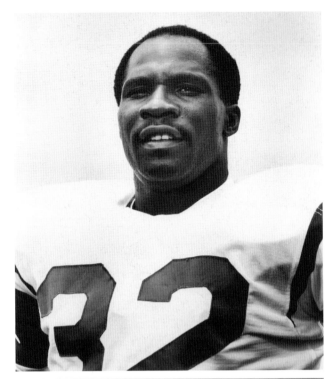

Emerson Boozer
Boozer was born on the Fourth of July in 1943 at his home in Richmond County. He played football for Lucy Laney High School in Augusta and Maryland State College (now the University of Maryland Eastern Shore) before earning a Super Bowl III championship ring in 1969. His playing years were with the New York Jets. He was inducted into the College Football Hall of Fame in 2010. (Courtesy the *Augusta Chronicle*.)

David Marion Dupree
Dupree is pictured, standing, watching a student sign a scholarship. He served as head coach at Lucy C. Laney High School in Augusta for 26 years, retiring in 1999. He was inducted into the Georgia Sports Hall of Fame in 1992. He served on the board of trustees of Augusta's historic Tabernacle Baptist Church, where he sang in the gospel and male choirs. He died on September 12, 2012. (Photograph by Nelson Harris, courtesy the *Augusta Chronicle*.)

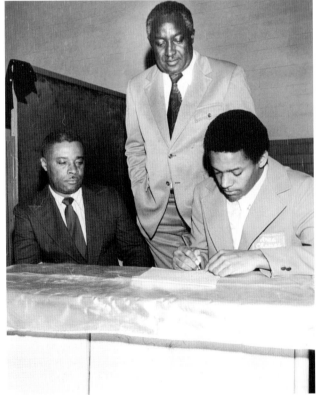

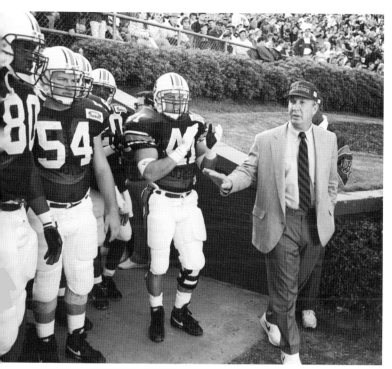

Pat Dye

Pat Dye, shown here with Auburn University players, was an athletic star at the Academy of Richmond County in Augusta. He and his brothers, Wayne and Nat, all played football for the University of Georgia under legendary coach Wally Butts. Pat was head coach of the Auburn University Tigers football team from 1981 until 1992. He was inducted into the College Football Hall of Fame as a coach in 2005. (Photograph by Dan Doughtie; courtesy the *Augusta Chronicle*.)

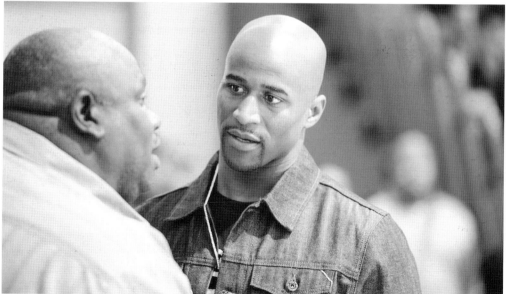

Deon Grant

Grant (right), pictured talking with Otis Smart, was a football star at Augusta's T.W. Josey High School when the team won a state title in 1995. He retired from the NFL in 2013, but not before helping the New York Giants win a Super Bowl title in the 2011 season. Grant spent two seasons with the Giants after playing for the Carolina Panthers, Jacksonville Jaguars, and Seattle Seahawks. His NFL record included more than 700 combined tackles, 30 interceptions, and 6.5 sacks. (Photograph by Michael Holahan; courtesy the *Augusta Chronicle*.)

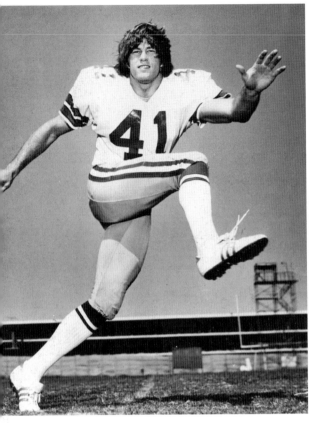

Charlie Waters

Waters grew up in North Augusta playing a variety of sports. His brother Keith went to Clemson on a baseball scholarship. Charlie played football well enough in high school to make the 1965 Shrine Bowl team as a quarterback. He was signed to a football scholarship at Clemson University that led to him playing with the Dallas Cowboys, making five Super Bowl appearances, and helping the Cowboys win two championships. (Courtesy the *Augusta Chronicle*.)

Charley Britt

Britt, born in Augusta, played football for North Augusta High School, like Charlie Waters. He became a star player for the University of Georgia and then professionally for the Los Angeles Rams. While in Los Angeles, Britt became the roommate of 1960s rock heartthrob Ricky Nelson and appeared on the Nelson family's television series. He later became a TV news anchor in Augusta. (Courtesy the *Augusta Chronicle*.)

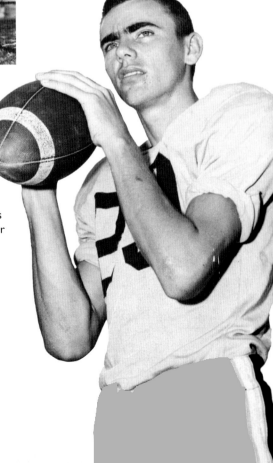

Hulk Hogan

Terry Gene Bollea was born in St. Joseph Hospital in Augusta (now known as Trinity Hospital) in 1953. His father, Peter, was working as a pipefitter at the Savannah River nuclear energy plant near Augusta. The family moved to Tampa, Florida, in the mid-1950s. Terry excelled in baseball and bowling and became a guitar player in a rock band called Ruckus. He got interested in wrestling, changed his name to Hulk Hogan—and the rest is history. (Photograph by Eric Olig; courtesy the *Augusta Chronicle*.)

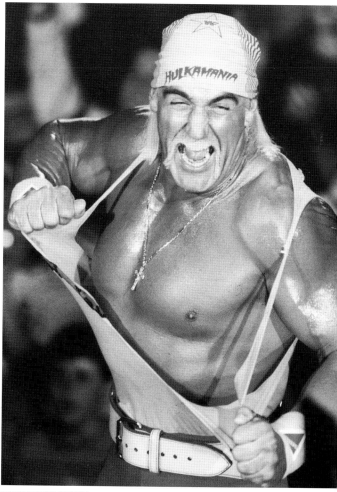

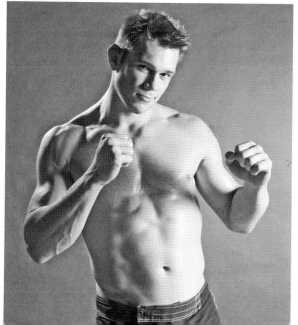

Forrest Griffin

Griffin graduated from Evans High School near Augusta, Georgia, and the University of Georgia in Athens and trained in mixed martial arts (MMA) fighting in Athens for five years. He was a Richmond County Sheriff's Department deputy in Augusta when asked to take part in the first-season of Spike TV's *The Ultimate Fighter* MMA reality show in 2005. He won the final round by unanimous decision. Griffin retired from MMA fighting in 2013, citing chronic injuries. (Courtesy the *Augusta Chronicle* and Spike TV.)

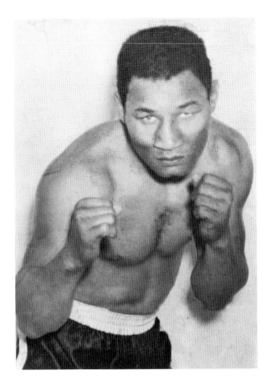
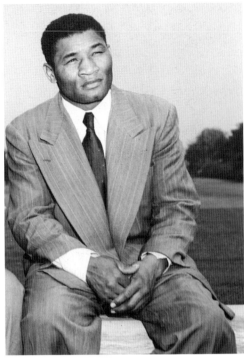

Beau Jack
Sidney "Beau Jack" Walker boxed 21 main events at Madison Square Garden in New York and twice held the New York Boxing Commission world lightweight title. He was born in Waynesboro, Georgia, and raised in Augusta. He made and lost millions and ended up shining shoes at the famous Fontainebleau Hotel in Miami, Florida. He was inducted into the Georgia Sports Hall of Fame in 1979 and died on February 9, 2000. (Both, courtesy the *Augusta Chronicle*.)

Forrest "Spec" Towns
Towns became the first Georgian named to the American Olympic track team and the first Georgian to win Olympic gold for competing in track and field in the 1936 Olympics. The native of Fitzgerald, Georgia, grew up in Augusta and played football at the Academy of Richmond County. He attended the University of Georgia on a football scholarship and eventually became UGA's assistant football coach and head track coach. (Courtesy the *Augusta Chronicle*.)

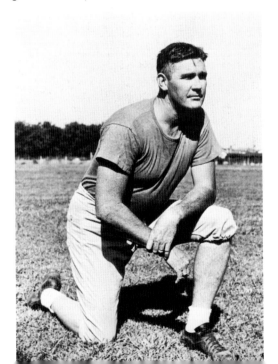

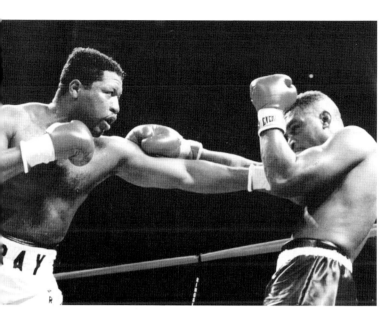

Ray Mercer

Former Augusta resident Ray Mercer entered the 1988 Summer Olympics in Seoul, Korea, as a champion amateur boxer and ended up earning a gold medal. He was born in Jacksonville, Florida, and grew up in Augusta. He went on to win a pair of world heavyweight titles during his professional career, compiling a record of 36 wins and 7 losses. He tried kickboxing and mixed martial arts briefly. (Photograph by Matthew Craig; courtesy the *Augusta Chronicle*.)

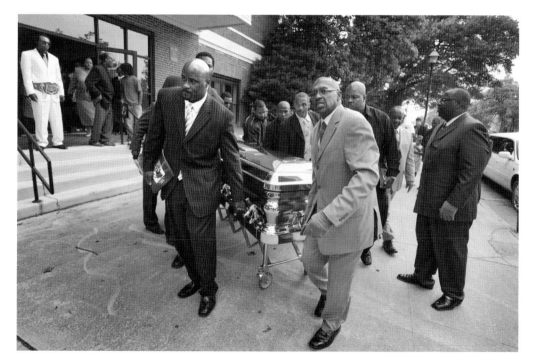

Vernon Forrest

Vernon Forrest, who grew up in Augusta and honed his skills at the Augusta Boxing Club, competed in the 1992 Olympic trials to earn a spot on the US team. He turned to professional boxing and became a two-time welterweight and two-time junior middleweight world champion. He was shot and killed at the age of 38 in 2009 when he stopped at an Atlanta convenience store to put air in the tires of his Jaguar. (Photograph by Michael Holahan; courtesy the *Augusta Chronicle*.)

Mitzi Edge

Mitzi Edge and her brother Cris both started playing golf in 1966 with their father, Ken, at Goshen Country Club in south Richmond County. At that time, Mitzi was six and Cris was three. She became Georgia Amateur Ladies Golf champion four times (1978–1981). Mitzi won five tournaments while attending the University of Georgia and was named a first team All-American in 1983 and 1984. She joined the Ladies Professional Golf Association Tour in 1984. (Photograph by Jim Middleton; courtesy the *Augusta Chronicle*.)

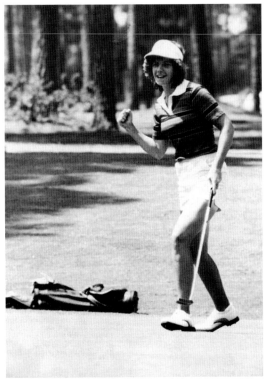

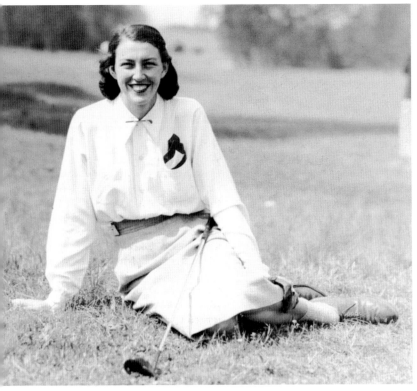

Eileen Stulb

Eileen Heffernan Stulb, a native and lifelong resident of Augusta, was the first woman to earn a spot on the golf team at Augusta College. She was a runner-up twice in the prestigious Titleholders Championship, considered the women's equivalent of the Masters Tournament. She won the Georgia Women's State Amateur Championship twice. She was inducted into the Georgia Golf Hall of Fame in 2004 and died February 26, 2007. (Courtesy the *Augusta Chronicle*.)

Vaughn Taylor
PGA Tour player Vaughn Taylor turned professional in 1999 after graduating from Augusta State University with a degree in business administration. He is especially proud of the American Junior Golf Association tournament named after him—the E-Z-GO Vaughn Taylor Championship that is played in the Augusta area—and of landing a 56-pound, 2-ounce striper in 2012 in the Savannah River just below Thurmond Lake dam, a species record for the river. (Photograph by Emilly Rose Bennett; courtesy the *Augusta Chronicle*.)

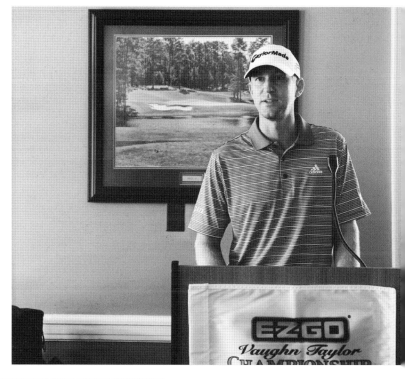

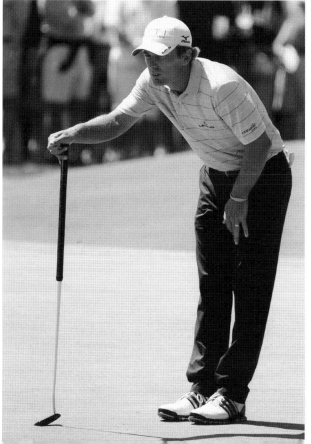

Charles Howell III
Howell, born and raised in Augusta, was introduced to golf at age seven by next-door neighbor Graham Hill. He graduated from Westminster Schools of Augusta and became a member of Oklahoma State University's golf team. He won the Haskins Award in 2000 for being the most outstanding collegiate golfer in the United States. He turned professional the same year and became a full-time PGA Tour player in 2002. (Photograph by Michael Holahan; courtesy the *Augusta Chronicle*.)

Dr. William Dickerson Jennings
Jennings not only was mayor of Augusta during the Depression years but also was a prominent and respected physician. The name of the city's baseball stadium, then on Walton Way near Fifteenth Street, was changed from Municipal Stadium to Jennings Stadium in honor of the sports-loving citizen. The Edgefield, South Carolina, native grew up in Augusta and acquired a degree in medicine from the Medical College of Georgia in 1902. (Courtesy the *Augusta Chronicle*.)

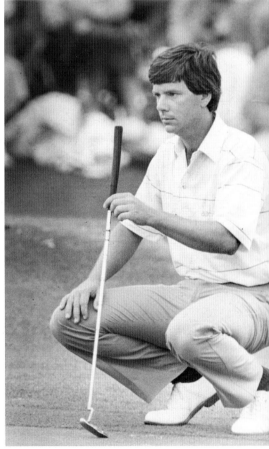

Larry Mize
Larry Hogan Mize was born on September 23, 1958, in St. Joseph's Hospital (now Trinity Hospital) in Augusta. He is the only native Augustan to win the champion's title of the Masters Tournament at the Augusta National golf course. He became only the third Georgia-born golfer to win the Masters when he captured the title in 1987. (Photograph by James M. Caieila; courtesy the *Augusta Chronicle*.)

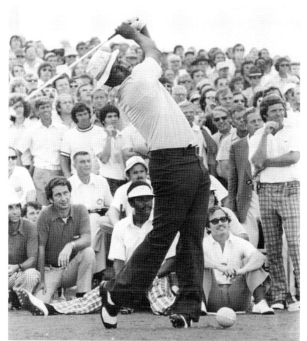

Jim Dent

Dent became interested in golf as a youngster, caddying at Augusta National Golf Club and the Augusta Country Club. He became a PGA Tour player and also played on the Senior PGA Tour (now called the Champions Tour), winning 12 tournaments between 1989 and 1998. He was inducted into the Georgia Golf Hall of Fame in January 1994 and named to the Georgia Sports Hall of Fame in 2008. (Courtesy the *Augusta Chronicle*.)

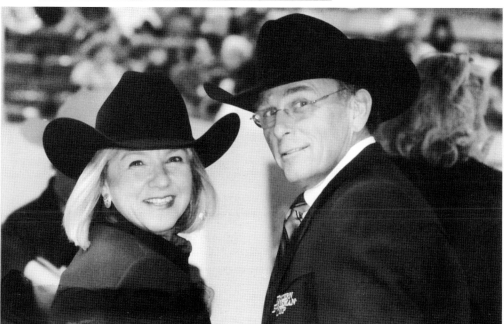

Sherry Fulmer and Pete May

The Augusta Futurity is the largest cutting horse event east of the Mississippi River, and the National Barrel Horse Association (NBHA) is the umbrella organization for barrel horse racers worldwide. The success of both of these Augusta-based organizations is due to Fulmer and May, who once worked together at Murray Biscuit Company in Augusta. May is one of five cofounders of the NBHA, which has grown to more than 22,000 members in several continents. (Courtesy Sherry Fulmer.)

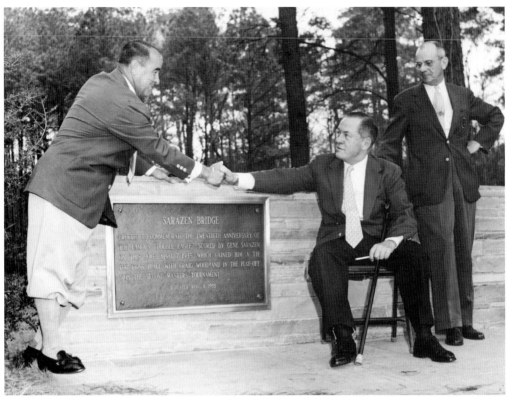

Bobby Jones and Clifford Roberts
Legendary amateur golf champion Bobby Jones (center) and New York investment banker Clifford Roberts (far right) cofounded the Augusta National Golf Club, with its inaugural tournament held in 1934. They are pictured with golfer Gene Sarazen for the dedication of the Sarazen Bridge. Jones won 13 major championships between 1923 and 1930. Roberts was chairman of the Masters Tournament from 1934 to 1976. (Photograph by Frank Christian Studio, courtesy the *Augusta Chronicle*.)

Phil Wahl Sr.
The day after what would be Clifford Roberts's last Masters Tournament in 1977, Roberts signed a photograph of himself and wrote on it "For Philip R. Wahl, The best club manager the Augusta National ever had or expects to have." Wahl was killed a year later, at age 43, in a traffic accident on Berckmans Road, ironically near the gates of the club. (Courtesy the *Augusta Chronicle*.)

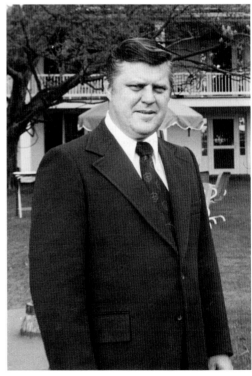

CHAPTER TWO

Community-minded Individuals

Like most major cities, Augusta has faced several crises that could have destroyed it or made it a stronger, better place.

Loyalists and Patriots, Yankees and Confederates, and all types of American soldiers have marched on Augusta's streets. First president of the United States George Washington spent a few days in town in 1791, during Augusta's 10 years as the capital of the state.

Floods reaching up to the knees of merchants have covered Broad Street, and fires, especially in 1916 and 1921, showed the vulnerability of the buildings and houses. Tornadoes tore down the main market on Lower Broad, where African American slaves were sold like cotton and vegetables.

Yet, Augusta kept surviving the crooked politicians, corrupt preachers, all-powerful law enforcement officers, cheating businessmen, and anti-women's rights, anti-racial rights, and anti-human rights people to become one of the largest cities in the American South.

Part of that is due to the average citizens who did not really seek fame but became famous because of the good deeds they did for others in a time when it was not expected, such as Emily Tubman, who released her slaves before the Civil War and paid for their passages back to Africa, or Amanda America Dickson Toomer, who became the richest black woman in the South when her white, slave-owning father in rural farming country near Augusta left her his wealth in his will. Though his white relatives challenged it, the Georgia Supreme Court agreed that the fair and rightful thing was to uphold his wishes and rule in his racially mixed daughter's favor. The magnificent house she had on Telfair Street near Fifth Street in the midst of wealthy, white neighbors can still be seen.

Augustans have done so much to care about fellow citizens who have been less fortunate. Many organizations have come to their aide, including the multimillion-dollar Salvation Army Kroc Center on Broad Street near Eve Street. Some homeless people still sleep under bridges, under hidden riverfront foliage, or in abandoned buildings, but many Augustans are working to make their lives somewhat better and somewhat safer, maybe giving them hope for the future.

Carrie Moore Adamson
Adamson, married to career US Army officer Raymond J. Adamson, served as president of the Fort Gordon Officers Wives Club, president of the Augusta Friends of the Library, and in many other community endeavors. Her real legacy is being cofounder, chartering president, and librarian of the Augusta Genealogical Society, which, in 2004, named its downtown building the Adamson Library in tribute to Carrie and Raymond, AGS charter members 1 and 1A. (Photograph by Andrew Davis Tucker; courtesy the *Augusta Chronicle*.)

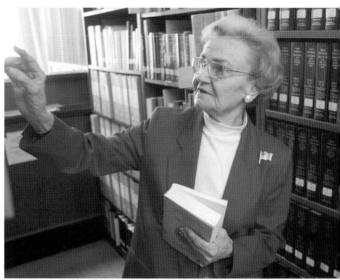

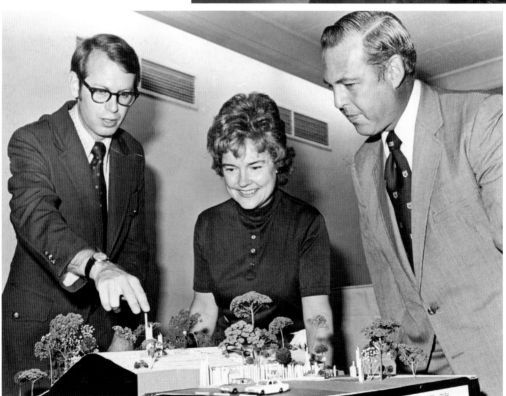

Nancy Anderson
Anderson, the wife of an Augusta doctor, is shown here with David Peet (left) and Bryce Newman in the early 1970s. She got tired of not being able to see the Savannah River standing on the levee downtown due to the heavy growth of trees and brush, so she began a movement that inspired thousands of volunteers to clear the heavy growth and build walking trails, a riverside amphitheater, and other things. Their efforts resulted in the creation of Oglethorpe Park. (Photograph by Lee Downing; courtesy the *Augusta Chronicle*.)

Dr. W.G. "Curly" Watson Jr.
Watson, who died in 2012 at age 102, delivered an estimated 15,000 babies over about 50 years at University Hospital. He also taught medical students and residents at his alma mater, the Medical College of Georgia. The Women's Center at University Hospital is named after him. The Medical College of Georgia (now Georgia Regents University) honored him with its Presidential Lifetime Achievement Award the year before he died. (Photograph by Margaret Sellers; courtesy the *Augusta Chronicle*.)

Thomas W. Greene
One of the Augusta area's most used recreational areas is the Greeneway, a paved running and bicycle trail that goes for more than seven miles over what was once a Norfolk Southern railroad line. Thomas W. Greene, mayor of North Augusta (South Carolina) from 1985 to 1997, was instrumental in creating the recreational path that is named for him. Here, Greene (left) is with his brother-in-law Buddy Hawkins. (Photograph by Randy Hill; courtesy the *Augusta Chronicle*.)

Clay and Braye Boardman
Clay Boardman (right) has renovated Enterprise Mill, Houghton School, and Sutherland Mill. He and Braye are also turning William Robinson School into condominiums. Braye (left), an active conservationist, was one of the founding members of the Central Savannah River Land Trust. Clay renovated the Widows Home on Greene Street and gave it to Christ Community Health Services to aid the underserved. The Ann Boardman Widows Home, named for their mother, opened for patients in August 2011. (Courtesy the *Augusta Chronicle*.)

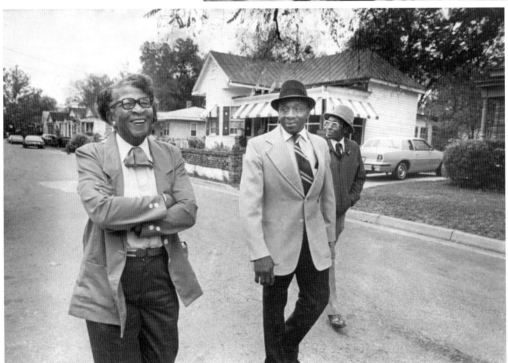

Addie Scott Powell
Powell, shown with Willie E. Cooper Sr. (center) and Charlie Griffin, died at age 90 on January 10, 2012, at her home in the Bethlehem section of Augusta that she loved. She was the founder and director of Bethlehem Area Community Association and was a renowned community activist and historic preservationist. She taught at North Carolina State University and Southern University in Louisiana, and she retired from the Brooklyn Public Library in New York. (Photograph by Judy Ondrey; courtesy the *Augusta Chronicle*.)

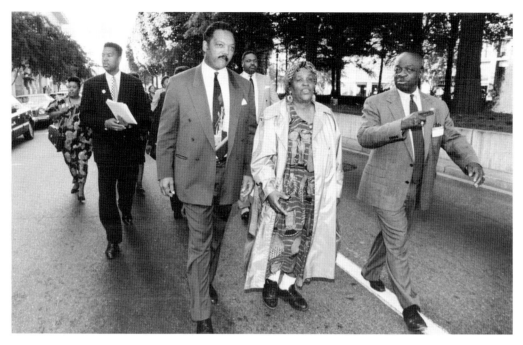

Emma Gresham
Gresham, pictured walking with Jesse Jackson (left) and Henry Howard (right), embarked on a 32-year teaching career in Augusta. She initially taught second grade, then taught 12- and 13-year-old mentally handicapped students. She officially served as mayor of tiny Keysville, Georgia, south of Augusta, from 1988 until 2005. Her influence on both the state and national levels resulted in Keysville having a fully functioning water and sewer service, street lights, a fire department, library, post office, wastewater treatment plant, after-school program, and municipal building. (Photograph by Matthew Craig; courtesy the *Augusta Chronicle*.)

Robert C. "Bobby" Daniel Jr.
The sanctuary of First Presbyterian Church was standing-room only when 50-year-old Daniel (at right, talking with Robert Dixon) died in 1993, just 11 days after being diagnosed with acute leukemia. He had been an attorney for the Richmond County government for 20 years, attorney for the Augusta-Richmond County Coliseum Authority, and twice president of the Georgia Association of County Attorneys. (Photograph by Margaret Moore; courtesy the *Augusta Chronicle*.)

27

Louisa Mustin

Louisa Mustin, who died in 1976, not only founded the Augusta Players in 1945 but also founded Planned Parenthood of Augusta and was a founding member of the Augusta Art Club in 1932. She also was past president of the Junior League and active in the League of Women Voters. In 1950, she personally built the first permanent theater in America exclusively for the presentation of puppet plays, which lasted four years at 1469 Broad Street. (Courtesy Sam Singal.)

Linda W. Beazley

This native Augustan served as executive director of the Richmond County Board of Elections from 1973 until 1993. She was appointed in 1996 to become Georgia's State Election Director and served in this capacity from 1997 until her retirement in 2005. She was the founding president of the Georgia Election Officials Association and the first female to chair the hospital authority board at University Hospital. (Courtesy the *Augusta Chronicle*.)

Richard S. "Dick" Fox
Fox, who died in 2010 at age 78, was known for both his professional success as founder of Fox Appliance Parts of Augusta and for his passion for the Augusta Rowing Club and other civic groups. He was a member of the South Augusta Rotary Club and past chairman of the Augusta Canal Authority and the Juvenile Court Review Board. He and his wife, Virginia, loved the Savannah River and Augusta. (Photograph by Fitz-Symms Studio; courtesy the *Augusta Chronicle*.)

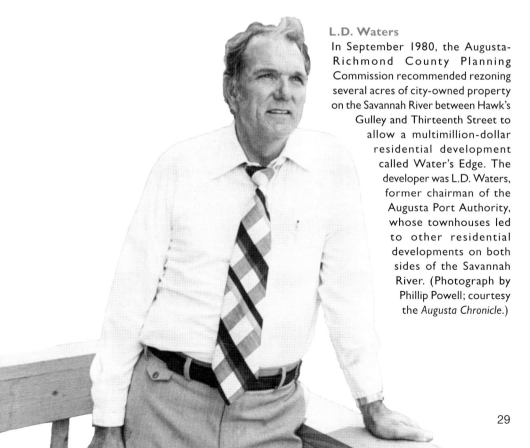

L.D. Waters
In September 1980, the Augusta-Richmond County Planning Commission recommended rezoning several acres of city-owned property on the Savannah River between Hawk's Gulley and Thirteenth Street to allow a multimillion-dollar residential development called Water's Edge. The developer was L.D. Waters, former chairman of the Augusta Port Authority, whose townhouses led to other residential developments on both sides of the Savannah River. (Photograph by Phillip Powell; courtesy the *Augusta Chronicle*.)

Frank Wills
One night in 1972, in the Watergate office complex in Washington, DC, security guard Frank Wills, who grew up in North Augusta (South Carolina), discovered a door latch that was taped over. That led to five nicely dressed burglars being caught in the headquarters of the Democratic National Committee, which eventually resulted in the resignation of Pres. Richard Nixon. Wills returned to North Augusta in 1990 and died 10 years later at age 52 in Augusta's University Hospital from a brain tumor. (Courtesy the *Augusta Chronicle*.)

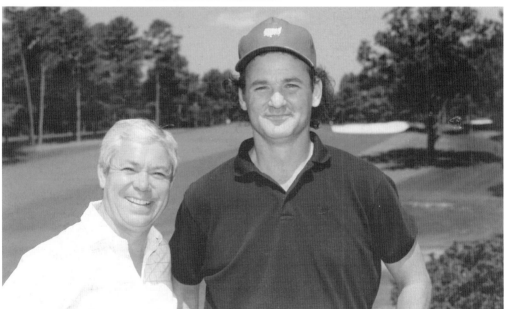

Frank Christian Jr.
Frank Jr. was the official photographer of the Augusta National Golf Club for more than 40 years. His father, Frank Christian Sr., was the club's official photographer from the 1930s to 1954 when he handed over the photo studio to his 19-year-old son. Frank Jr. used both his and his father's photographs in the book *Augusta National & The Masters: A Photographer's Scrapbook* (Sleeping Bear Press). He has been hired to photograph many celebrities, including singers James Brown and Frank Sinatra. Here, Frank Jr. (left) is seen with movie and television actor Bill Murray at the Augusta National golf course. (Courtesy the *Augusta Chronicle*.)

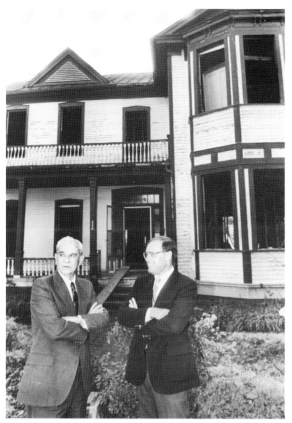

Peter Knox Jr.

By the late 1970s, the former Sacred Heart Catholic Church building was so deteriorated and abandoned that there was talk of tearing it down. The church had been dedicated in 1900 and had its last Catholic service in 1971. The variety of bricks to build the church came from Hamburg, South Carolina, which once existed across the Savannah River from downtown Augusta. However, local philanthropist Peter S. Knox Jr., shown at left with Herb Upton, stepped up to the plate and invested millions to restore the church to its former glory as the Sacred Heart Cultural Center. It now is one of Augusta's most used buildings for weddings, concerts, receptions, arts festivals, and other gatherings. Knox also invested a fortune in restoring many early 1900s houses in Augusta's historic Old Town neighborhood on lower Greene and Telfair Streets. (Left, photograph by Steve Thackston, courtesy the *Augusta Chronicle*; below, photograph by David H. Nash, courtesy the *Augusta Chronicle*.)

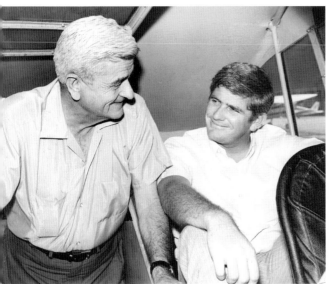

Forrest Boshears and Willis "Buster" Boshears Sr. More than 10,000 Augusta-area aviation fans have shown up annually for the Boshears Skyfest, which began in 1991 as the Boshears Memorial Fly-In. It honors brothers Forrest Boshears and Willis "Buster" Boshears Sr., pioneers of general aviation in the Augusta area. The renovated terminal at Daniel Field airport in 2012 was renamed Boshears Terminal. The brothers are in the Georgia Aviation Hall of Fame. This photograph shows Willis Sr. with his son Buster. (Courtesy the *Augusta Chronicle*.)

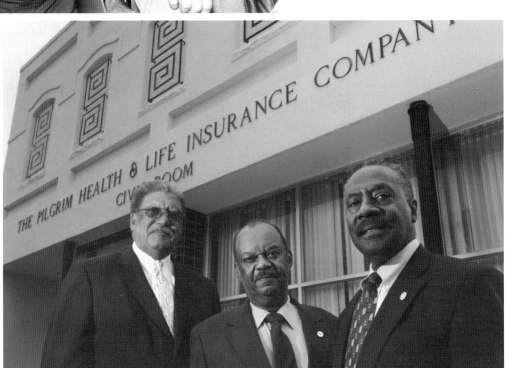

Solomon William Walker II
Walker (left), pictured with Walter Hornsby III (center) and Joseph Greene, was as physically impressive at six foot, nine inches as he was with his business and personal life. The former chief executive officer and chairman of the board of the Pilgrim Health and Life Insurance Company died in 2013. Walker retired from the Medical College of Georgia, where he was director of the Office of Affirmative Action and Equal Employment Opportunity. His grandfather Solomon W. Walker cofounded the Pilgrim Company in 1898 as Georgia's first black-owned insurance company. (Photograph by Chris Thelen; courtesy the *Augusta Chronicle*.)

Grover Cleveland Maxwell
Maxwell was 95 when he died in 1983. He and his two brothers developed Maxwell Brothers into a chain of more than 35 retail furniture stores. He was a founder of First Federal Savings and Loan Association of Augusta, which became Bankers First, and funded many educational scholarships. The Grover C. Maxwell Performing Arts Theatre, with its 740 seats at GRU Summerville (formerly Augusta State University), is named after him. (Courtesy the *Augusta Chronicle*.)

Paul Menk
Over the past few decades, native Augustan Paul Menk has experienced the changes of the banking industry in Augusta first hand, beginning with his passbook savings account at the Georgia Railroad and Banking Company. That bank evolved into First Union of Augusta for which Menk worked in the commercial lending department. First Union evolved into Wachovia which evolved into Wells Fargo—all in the same downtown Augusta building. In 2009, Menk was named manager of Wells Fargo's Greater Georgia Business Banking Division, responsible for business banking in all Georgia cities and markets outside of metro Atlanta. Menk's father, Peter Menk, likewise was a well-known banker who served on the board of directors of the Georgia Railroad and Banking Company. He was also a past president of the Augusta Builders Exchange. (Photograph by Chris Thelen; courtesy the *Augusta Chronicle*.)

Duncan Wheale

Up until young Augusta lawyers Duncan Wheale and Tom Harley were appointed to the Augusta Port Authority, the authority members envisioned the Savannah River for shipping goods to Savannah, not for recreational development. Wheale and Harley had been exposed to collegiate regatta rowing and came up with a proposal for the Augusta Invitational Rowing Regatta, even though there were no rowing boat docks existing downtown. Then-Augusta mayor Edward McIntyre jumped on the bandwagon and allocated $50,000 from his mayoral discretionary fund for the docks and other regatta funding. The first Augusta Invitational Rowing Regatta was held on April 7, 1984, with 13 participating collegiate teams. Wheale, who also helped bring about the multimillion-dollar Kroc Center, eventually became a Richmond County superior court judge. (Above, photograph by Lannis Waters, courtesy the *Augusta Chronicle*; right, courtesy Don Rhodes.)

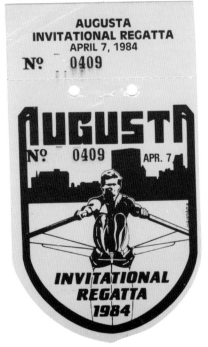

AUGUSTA
INVITATIONAL REGATTA
APRIL 7, 1984
N⁰ 0409

AUGUSTA

N⁰ 0409 APR. 7

INVITATIONAL
REGATTA
1984

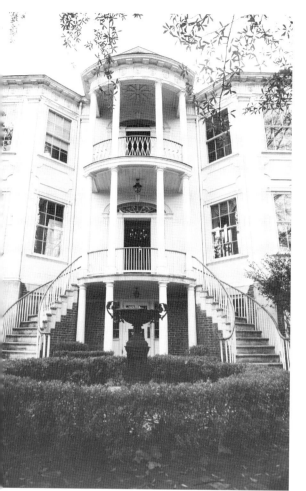

Gertrude Herbert Dunn

Olivia Antoinette Herbert, an Augusta winter resident, wanted to honor her late daughter, Gertrude. So, in 1937, she bought this magnificent, deteriorating Federal-style home at 506 Telfair Street that was built by Augusta mayor Nicholas Ware around 1818, and donated it to the Augusta Art Club for its permanent home. The club promptly assumed the name of the Gertrude Herbert Institute of Art. (Photograph by Jon-Michael Sullivan; courtesy the *Augusta Chronicle*.)

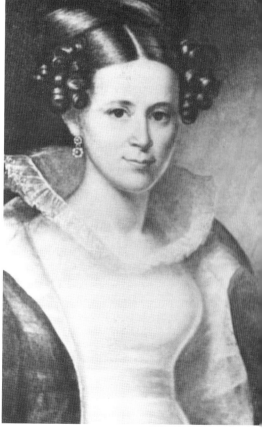

Emily Harvey Thomas Tubman

Tubman grew up in Frankfort, Kentucky, where she is buried. She moved to Augusta in 1818 and married Richard C. Tubman. She became executor of his estate when he died and paid the way for 68 of her slaves to go live in Liberia. One of their descendants became the president of Liberia. She also gave money to build scores of Christian churches throughout Georgia. (Courtesy the *Augusta Chronicle*.)

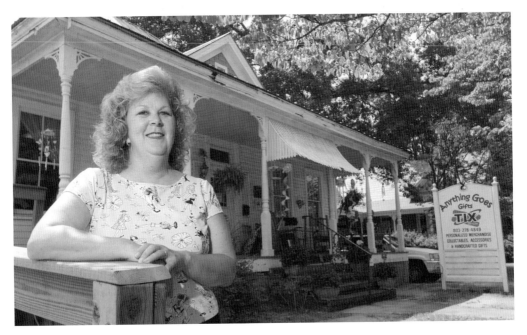

Elizabeth Oakley Norris
One of the largest musical events held annually in Augusta is the "A Day in the Country" music spectacular, which began in 1986. Elizabeth Oakley Norris helped produce the first festival and eventually became its owner and head honcho. She is also the owner and operator of the Anything Goes gift shop in North Augusta and TIXonline, a website for selling concert tickets. She is known for promoting many community endeavors. (Photograph by Chris Thelen; courtesy the *Augusta Chronicle*.)

Diana and Kelly Combs
This couple, who met as students at the University of Nebraska, never thought they would be the saviors of two white-columned, Augusta-area mansions. In 2009, Diane and Kelly bought the bank-owned Rosemary Hall and Lookaway Hall, built at the turn of the 20th century in North Augusta (South Carolina) by the city's cofounders, brothers James U. and Walter Jackson. The couple moved to North Augusta from California and took on operating the two mansions as bed-and-breakfast destinations. (Courtesy Don Rhodes.)

CHAPTER THREE

Business Leaders

One can still go to the Savannah River along Broad Street, near Eve Street, and along the Augusta Canal near Fifteenth Street and see the remains of what once were mighty textile mills that were the heart of Augusta's economy in the 1800s. Canal water used to provide power to the mills.

But with the riches that came to the owners of those mills came also sorrow and a sad way of living for the hundreds of workers whose lives were spent working with the looms and being indebted to the mill owners, who provided the shotgun shacks in which they lived. They really did owe their souls and just about everything else to the company store, as Tennessee Ernie Ford later sang about coal-mining families.

As major businesses developed in the Augusta area, good jobs came for some, and those jobs gave them financial freedoms that they had not known about while growing up on local farms or while trying to better themselves without college educations.

Giants of Southern competitive enterprises that became nationally and internationally known had their roots in Augusta, including Georgia-Pacific paper products, Western Sizzlin' steakhouses, Castleberry's canned goods, Maxwell Brothers furniture stores, E-Z Go and Club Car golf carts, James Brown's radio stations, media empire Fuqua Industries, Murray Biscuit Company, and others.

A former Augustan named Emanuel Wambersie came to the city from Belgium in the late 1700s and created a coastal boat-shipping company. That company still exists in Rotterdam today, more than 200 years after Wambersie was living in Augusta, operating a popular entertainment place next door to where the Georgia General Assembly was meeting.

Likewise, smaller businesses have kept Augusta's economy thriving by producing unique items and services that can be found throughout the world. Augusta may not be known as one of the nation's leading manufacturing centers, but tell that to the millions of people worldwide who use the products that were created in this area.

British general James Edward Oglethorpe had the vision to see that Augusta could be commercially successful as an inland fur-trading center between white settlers and the many Native American tribes who lived in the area. He believed the endeavor could lead to good things for the new colony of Georgia.

And apparently he was right.

Clem Castleberry

Castleberry's name is on the labels of millions of canned goods. He learned about perishable food from his father, who ran a grocery store on Broad Street in Augusta. Castleberry took advantage of housewives discovering that food products lasted a lot longer in cans, and he grew the company from 6 workers to more than 200 employees. It is now a $25-million-a-year business.

Castleberry loved football so much that in 1925 he and some of his friends formed the Hasbeens football team "composed of former college, high school, prep school and grammar school stars and those who have never made one of these teams" to challenge "any team in the country regardless of creed, color or of previous condition of servitude." The *Augusta Chronicle* article about the team said Castleberry was the "head football mentor." (Photograph by Robert Symms; courtesy the *Augusta Chronicle*.)

John L. Murray Sr.

Murray started Murray Biscuit Company in 1940 with an investment of $500. He began making vanilla wafers with an oven that would only hold four cookie sheets. He and son John L. Murray Jr. expanded their brand to include Jack's and Jackson Cookie Company. In 1965, the company was sold to Beatrice Foods. It became part of the Keebler Company in 1998 and later was part of the Kellogg family of brands. (Photograph by Robert Symms; courtesy the *Augusta Chronicle*.)

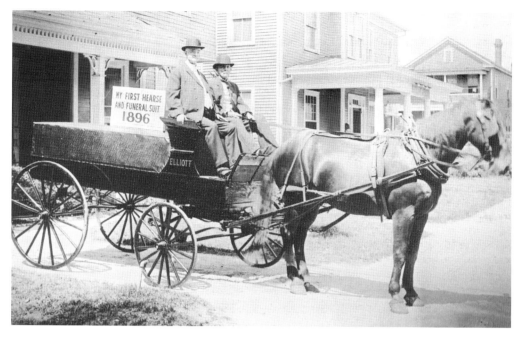

R. Edward Elliott Sr.
Elliott, sitting at left, started his first undertaking establishment in 1896, above his furniture store on Broad Street. The funeral home soon moved to Eleventh and Ellis Streets, where it continued to grow and moved to a large building on Telfair Street after World War II. The Telfair building closed in 2013, leaving two other Elliott Sons Funeral Homes, one on Lumpkin Road in Richmond County and the other on Columbia Road in Martinez. (Courtesy the *Augusta Chronicle*.)

Charles A. Platt
Platt's Funeral Home in Augusta began in 1837 when New Yorker Charles A. Platt opened Platt's Furniture Emporium on Broad Street. He began selling coffins and handling the funerals of Augusta's most distinguished citizens. He helped organize the Clinch Rifles in 1861 at the start of the Civil War and helped with the funerals of top Confederate generals. Platt's eventually moved to the old Bohler Mansion on Crawford Avenue, where it is today operated by the Curtis family. (Courtesy Don Rhodes.)

39

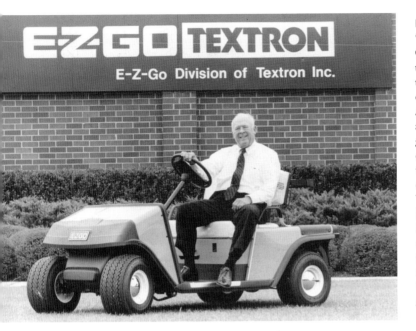

Billy and Beverly "Bev" Dolan
On June 13, 1954, these two brothers started the E-Z-GO golf car company in a garage in Augusta. It was the day after Bev, shown with his golf cart, had gotten out of the military. In 1960, the brothers sold their company to Textron. They both stayed on board until 1978, when Billy left with some other employees and investors to purchase the Club Car Company. (Photograph by Walt Unks; courtesy the *Augusta Chronicle*.)

Bill Stevens
Bill Stevens Jr. and son Bill Stevens III stand next to a portrait of Bill Stevens Sr. In 1962, the senior Stevens purchased Landreath Machine, which was founded in Dallas, Texas, in 1958 to produce some of the nation's first golf cars. Stevens moved the company, which became Club Car, to Augusta. He sold the company in 1978 to eight senior executives and managers from Augusta-based E-Z-GO. Ingersoll Rand purchased Club Car in 1995. The one millionth Club Car vehicle came off the production line on March 9, 2001. (Photograph by Michael Holahan; courtesy the *Augusta Chronicle*.)

Craig Calvert

Calvert moved from Michigan to Augusta in 1972 to take over the Green Jacket restaurant, first at Daniel Village and also when it moved across Washington Road from the Augusta National Golf Club. He opened his own restaurant, Calvert's Restaurant, in Surrey Center in 1976 when he was 26. Many leading chefs learned from Calvert and opened their own successful, upscale restaurants. Helping Calvert succeed has been his wife, Beverly, and sister Kathy Moore. (Photograph by Judy Ondrey; courtesy the *Augusta Chronicle*.)

Chuck Baldwin

Baldwin has been a co-owner of French Market Grille on Highland Avenue in Surrey Center for more than 25 years. He worked with Craig Calvert at the Green Jacket restaurant in Augusta for several years, and, for awhile, he was the assistant manager of Calvert's Restaurant. Baldwin and his wife, Gail, opened the French Market Grille cajun-food restaurant in 1984, with the couple and Calvert being 50-50 owners. One year later, the Baldwins bought out Calvert's stock and became sole owners. (Photograph by Rainier Ehrhardt; courtesy the *Augusta Chronicle*.)

Kevin Goldsmith
One of Augusta's most successful restaurant developers, Goldsmith gained a popular reputation with the small Green Scallion restaurant, located on the corner of Seventh and Broad Streets in what was once a tire store owned by baseball legend Ty Cobb. That led to Goldsmith's other restaurant on Broad Street, Goldsmith's Pullman Hall in the old train depot building, and the unique Takosushi in nearby Evans, Georgia. (Photograph by Kendrick Brinson; courtesy the *Augusta Chronicle*.)

Dave and Steve Kaplan
Dave Kaplan's mother, Sarah Greenberg, remarried after her first husband died and moved to Augusta, where she opened Sunshine Bakery in 1946, with her second husband serving as the baker. Dave (left) and his brother Erving moved to Augusta after World War II to help their mother run the business, which evolved into a popular restaurant. Dave's son Steven (right) took the reins in 1991. (Left, photograph by Andrew Davis Tucker; right, photograph by Annette M. Drowlette; both, courtesy the *Augusta Chronicle*.)

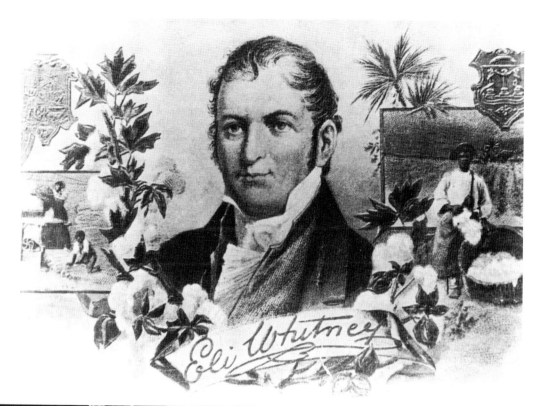

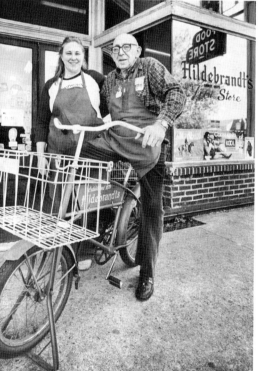

Eli Whitney
Whitney began developing his cotton gin at Mulberry Grove, a plantation near Savannah owned by Catharine Greene, the widow of Revolutionary War hero Nathanael Greene. He reportedly started his first successful cotton gin business in Wilkes County near Washington, Georgia, in 1795. There is a house on Eighth Street in Augusta that is said to have been Whitney's. The S.M. Whitney Company was started in 1868 by a descendant of Eli Whitney and continued in Augusta until 2013. (Courtesy the *Augusta Chronicle*.)

Luann and Louis Hildebrandt
German-born Nicholas Hildebrandt started Hildebrandt's grocery store in 1879 at Sixth and Ellis Streets in Augusta. Today, it is run by fourth-generation owner Luann Hildebrandt, shown here with her father, Louis. Her deli sandwiches are legendary. She and her seven siblings were raised on the second floor of the store. She started working there as a child in 1960, spent some time working as a school teacher, and returned to the store in 1974. (Photograph by Judy Ondrey; courtesy the *Augusta Chronicle*.)

Harry and Ostella Fulcher
Harry (pictured) and Ostella originated T's Seafood Restaurant, one of Augusta's best-known dining establishments, in 1946 on Miller's Pond near McBean, Georgia, in south Richmond County. "T" is Harry's family nickname. The couple built the current location on Mike Padgett Highway (Georgia Highway 56) near Bobby Jones Expressway in 1952. Georgia governor Sonny Perdue in 2010 named the nearby bridge over Bobby Jones Expressway the H.G. "T" Fulcher Bridge. (Courtesy the *Augusta Chronicle*.)

Nicholas Ballas
Luigi's Italian restaurant in the 500 block of Broad Street was opened in 1949 by Nicholas Ballas. It was passed on to his son Chuck Ballas (right) in 1961, then to grandson Chuck Ballas Jr. (left). Some of the most famous golfers and other celebrities have dined at Luigi's during the annual Masters Tournament. One of the special charms of Luigi's are the coin-operated jukeboxes on the tables that play classic music from the 1940s. (Photograph by M. Annette Drowlette; courtesy the *Augusta Chronicle*.)

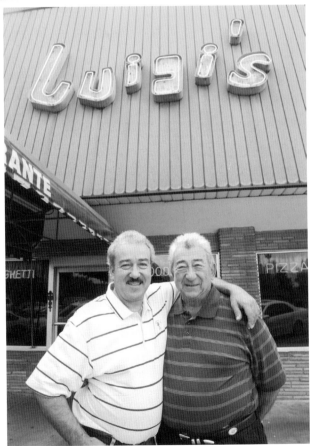

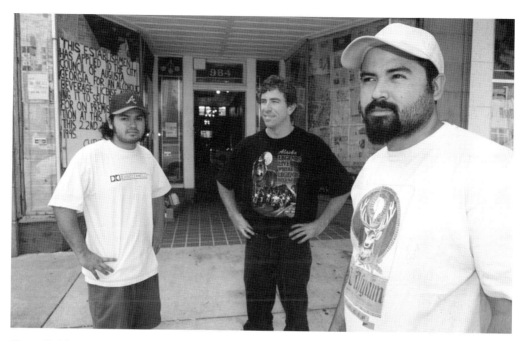

Coco Rubio

Coco (right), pictured with Jayson Rubio (left) and Terry Brogan Jr. (center), was a former high school Spanish teacher when he and his brother Jayson opened the Soul Bar nightclub at 984 Broad Street in 1995. His friends Barry Blackston and Matt Flynn opened nearby Nacho Mama's a few months later, and the two new businesses fed off each other's positive energy. The Rubio brothers teamed up with former Soul Bar bartender Eric Kinlaw to open the 500-person-capacity Sky City live music venue in 2008. (Photograph by Matthew Craig; courtesy the *Augusta Chronicle*.)

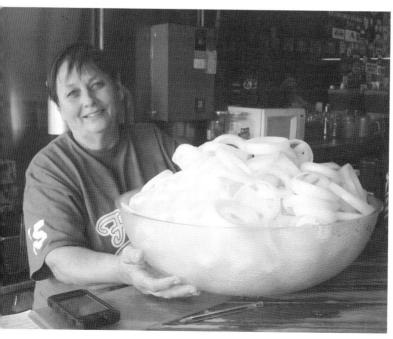

Sandi Watkins

For 28 years, Watkins has been dispensing Augusta history along with her famous cheese burgers and onion rings at Sports Center restaurant on Broad Street that her husband, Bill, had operated prior. Watkins is on her third grill, also used in the front window by her son and assistant manager, Travis. The restaurant cooks about 100 hamburgers a day and goes through 200 pounds of onions a week. (Courtesy Don Rhodes.)

Bonnie Ruben
Ruben has been president of BR Investment Group, which owns the more than 100-year-old Ruben's Department Store, the Ramada Plaza Hotel, and other properties. In 2002, she became one of the few women and, as a practicing Jew, one of the few non-Christians to run for mayor of Augusta. Her family business, Ruben's Department Store, gave Augusta's African American citizens credit in a day and age when they were seldom afforded that opportunity. (Photograph by Mark Dolejs; courtesy the *Augusta Chronicle*.)

Owen Robertson Cheatham
In 1927, Cheatham founded the Georgia Hardwood Lumber Company in Augusta, which changed its name to Georgia-Pacific Plywood & Lumber Company in 1948. The company moved its headquarters to Atlanta and became one of the world's leading manufacturers and distributors of tissue, pulp, paper, toilet paper, paper-towel dispensers, and other products, with more than 40,000 employees at more than 300 locations. Its brand names include Angel Soft, Quilted Northern, and Brawny. (Courtesy the Georgia Department of Economic Development.)

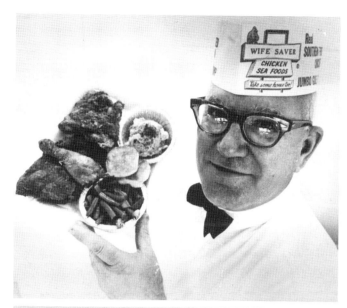

George B. Cunningham Jr.
Wife Saver country cooking restaurants began in 1965 when Cunningham needed a way to help pay off mounting medical bills due to his son Chris (now the Wife Saver owner) having polio. The original Wife Saver stood on Milledgeville Road in the front yard of George's home. Chris and his brother Robert were often called away from baseball games to make banana pudding or biscuits. Wife Saver now has several franchises in Georgia and South Carolina. (Courtesy the *Augusta Chronicle*.)

Sherman Drawdy
Drawdy, shown here with his wife, Fairy, in 1953, became the first Augusta banker named an officer of the American Bankers Association when he was elected treasurer of the organization at its 79th gathering in Washington, DC. He previously had been president of the Georgia Bankers Association. Drawdy was chief executive officer and board chairman of the Georgia Railroad Bank and Trust Company when he died in 1973. (Courtesy the *Augusta Chronicle*.)

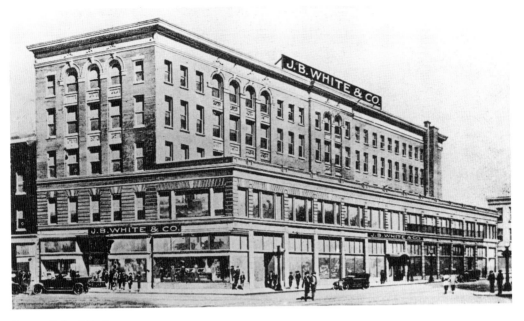

James Brice White

Irish immigrant White in 1874 founded his J.B. White's department store in Augusta. He sold his store in the early 1910s to the H.B. Claflin Company, which owned other department stores, including Lord & Taylor, and spent his retirement years in Italy. He still supported the community that brought him his wealth through the construction of a YMCA in Augusta and the creation of a scholarship offered to students at Augusta State University (now GRU Summerville). His original White's store was expanded into a chain, which mostly became Dillard's. Most locations were in South Carolina, though locations existed in Augusta and Savannah. The defunct Augusta store in the 900 block of Broad Street, built in 1924, was purchased in June 2007 and converted into condominiums. Former first lady Mamie Eisenhower shopped at this store. (All, courtesy the *Augusta Chronicle*.)

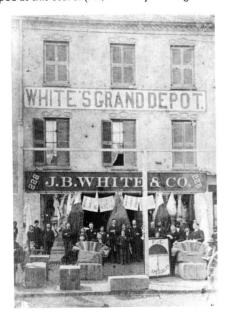
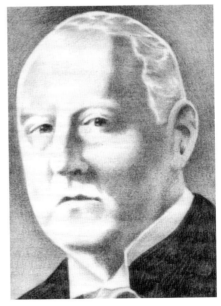

W.J. Heffernan
Heffernan, shown here at age 86 with grandchildren Susan (left) and Mary Lee, for many years operated the Town Tavern restaurant on Broad Street near Seventh Street, beginning in 1937. It moved a block away to Seventh Street at the levee when the Georgia Railroad Bank ant Trust Company (now Wells Fargo) was built using the land. Heffernan earlier operated another fine-dining place called Stulb's. The Town Tavern was the favorite Augusta watering hole for world-famous novelist Erskine Caldwell, who once lived in the Augusta area. (Courtesy the *Augusta Chronicle*.)

John Brooks "J.B." Fuqua
Fuqua's multimillion-dollar empire began with radio and television stations and evolved into Fuqua Industries. As chairman of the Democratic Party of Georgia, he helped get Augusta-native Carl Sanders elected governor in 1962. Fuqua donated more than $100 million to worthy causes. WJBF television, which he started in Augusta, bears his initials. He also donated Augusta's historic Montrose mansion to Reid Memorial Presbyterian Church to honor his teenage son Alan, who had been killed in a plane crash. Fuqua (right) is pictured with Augusta State University president Bill Bloodworth. (Photograph by Andrew Davis Tucker, courtesy the *Augusta Chronicle*.)

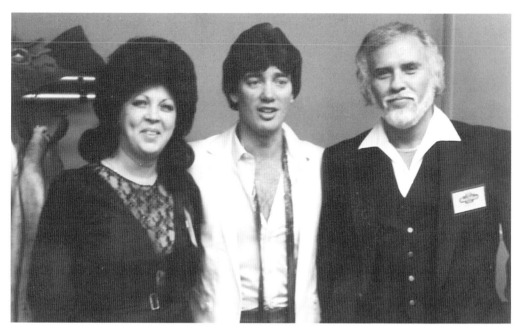

Kaye Crawford Mann
Mann's love of Elvis Presley was legendary even though she never met him or saw him perform in person. She not only had her very popular Kaye's Corner nightclub in North Augusta Plaza, but she also successfully ran several moving companies including the Moving Mann. She and her husband, Gene, are shown here flanking Ronnie McDowell, the singing voice for Presley in several television film biographies. (Courtesy Don Rhodes.)

Pat Blanchard
In 2008, Blanchard (standing, center) retired as president and chief executive officer of Georgia-Carolina Bancshares, Inc., which, in December 2007, had assets of about $447 million. His accomplishments include the formation of and being the chief executive officer of three community banks and two bank holding companies in Augusta and serving as a chairman of both the Metro Augusta and Columbia County Chambers of Commerce. He was the first inductee into the CSRA Business Hall of Fame and was co-owner of WMTZ country music station in Martinez, Georgia. (Courtesy the *Augusta Chronicle*.)

CHAPTER FOUR

Powerful Politicians and Judges

From almost the very beginning of its history, Augusta became a major base of political influence for the entire state of Georgia and the entire Southeast. US senators and representatives, many state governors, and other top US officials all came from the area.

Two signers of the Declaration of Independence and one signer of the Constitution are buried within blocks of each other in downtown Augusta.

Woodrow Wilson, who spent 10 years living in Augusta, saw the horrors of the Civil War and eventually became president of the United States. He tried to bring about peace through the League of Nations, which evolved into the United Nations. His next-door buddy, Joe Lamar, became a member of the US Supreme Court and minister to Spain.

Several Georgia governors in the 18th century came from Augusta, but, in the 20th century, only one Georgia governor came from Augusta: Carl Edward Sanders Sr. He was the product of pro-segregation political kingmakers from Augusta, including Roy V. Harris, former speaker of the Georgia House of Representatives. Although Sanders grew up in segregated times and came to state-wide power in the 1960s when feelings about integration were especially hateful and deadly in Augusta, Sanders led the South and the nation in peacefully integrating the Atlanta Public School System along with far-sighted mayor Ivan Allen Jr.

Many presidents loved spending their relaxation time in Augusta, including William Howard Taft and Dwight David Eisenhower, who called the area their second home. Even Abraham Lincoln's son Robert Todd Lincoln loved coming to this area in the early 1900s with his good friend Marshall Field, owner of the famous Chicago department stores. No matter what party has been dominant in Augusta during its history, politicians from all parts of the political spectrum have loved spending time in the Augusta area.

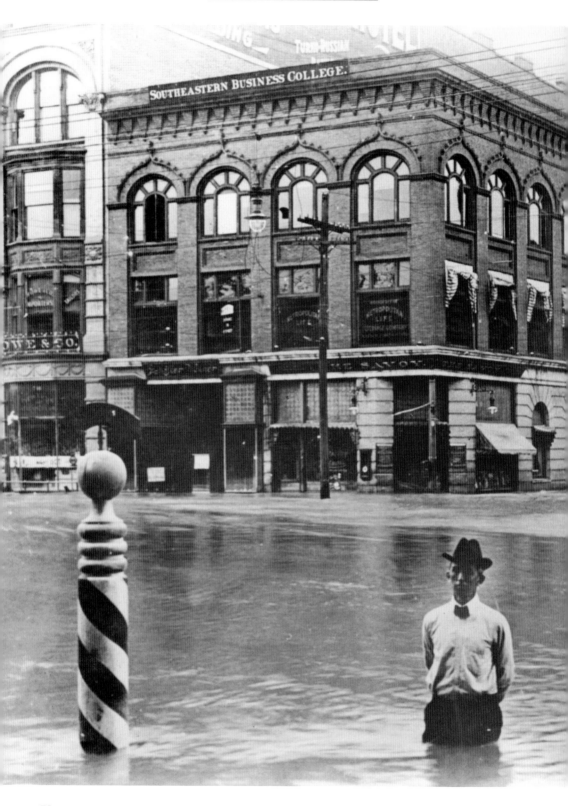

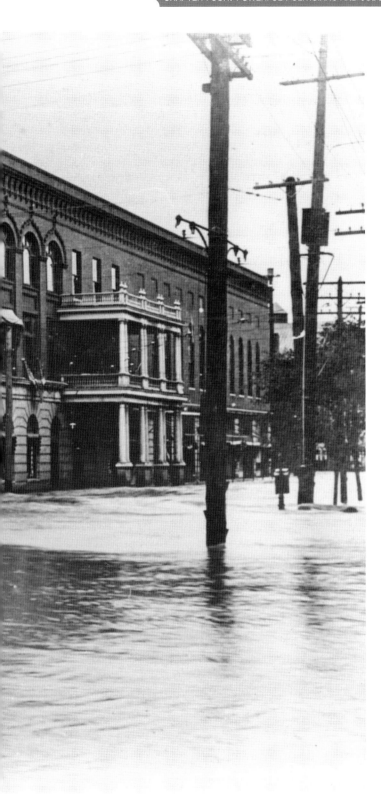

Judge Henry Hammond
Hammond, a Richmond County superior court judge and a former member of the Georgia General Assembly, died at age 92 on July 26, 1961. He is pictured here during an Augusta flood. His grandfather James H. Hammond was both governor of South Carolina and a US senator. Hammond retired from the bench in 1918 but continued to practice law in Augusta for 26 years. He spent his final years at his estate on Walton Way Extension, tending to 15 acres of his camellia gardens and 99 holly trees. Hammond, who never married, was known in his 20s as a spirited young man. When a local Augustan offered $50 to any person who could swim five times across the Savannah River without resting, Hammond, as a 25-year-old lawyer in 1894, accepted the challenge. He completed the swim in just over an hour. (Courtesy the *Augusta Chronicle*.)

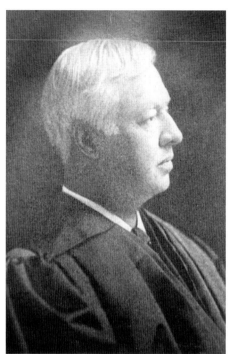

Joseph Rucker Lamar
In 1911, Pres. William Howard Taft appointed Lamar to the US Supreme Court, where he served until his death in 1916 at age 58. Lamar lived in Augusta from ages 3 to 18 while his father, James Sanford Lamar, served as pastor of the First Christian Church. Lamar's close next-door friend was Tommy Wilson, who later became Pres. Woodrow Wilson. Lamar codified the laws of Georgia in 1896 and served on the Georgia Supreme Court from 1902–1905. (Courtesy the *Augusta Chronicle*.)

Dudley H. Bowen Jr.
In 2006, a portrait of US district court judge Bowen was unveiled at the historic courthouse in Augusta where he had dispensed justice for 25 years. Bowen, after earning his law degree, practiced for one year before serving as an army lieutenant from 1966 to 1968. He returned to Augusta and practiced law until Pres. Jimmy Carter nominated him to the federal bench. (Photograph by Andrew Davis Tucker; courtesy the *Augusta Chronicle*.)

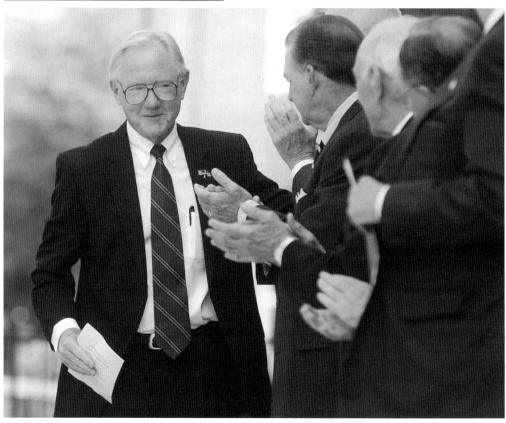

Richard Roundtree

Roundtree made history in November 2012 by becoming the first black sheriff of Richmond County. His family moved from his grandparents' small farm near Keysville, Georgia, to Augusta when he was six. He graduated from T.W. Josey High School in 1987, playing trombone in the band and football. He had been a part-time security officer at Regency Mall when hired by the Augusta Police Department in 1993. He moved to the sheriff's department in 1996 with consolidation, working with crime suppression, property crimes, and homicides. He was doing public safety for the Richmond County Board of Education when he ran for sheriff. (Courtesy the *Augusta Chronicle*.)

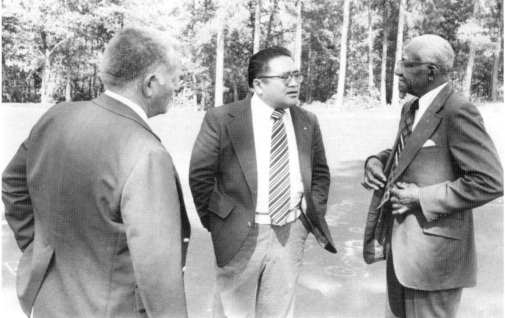

Madison Woo

In 1970, Woo (center) was elected a Richmond County Commissioner and became the first Asian American to hold an elected office in Richmond County. The Augusta native was a successful businessman with Chinese restaurants and other ventures. He became a lifetime member of the insurance industry's Million Dollar Roundtable as a salesman. He also served as president of the Augusta Chinese Consolidated Benevolent Association, district governor of the Lions Club International, and president of the National Hills Lions Club. He sang in the St. Mark United Methodist choir for nearly 50 years. (Photograph by Lee Downing; courtesy the *Augusta Chronicle*.)

William Few Jr.

One would think it would be enough for William Few Jr. to be both a Revolutionary War hero and one of Georgia's two signers (along with Abraham Baldwin) of the US Constitution, but he was much, much more. His burning desire for patriotism and freedom was ignited by British loyalists destroying the Few family farm and hanging his brother James without trial for opposing the British rule in North Carolina. That led the Few family to move to Georgia, where Few served as one of Georgia's original US senators, a member of the Georgia General Assembly, and a circuit court judge. In 1799, Few moved to his wife's state of New York, where he became a member of the New York State Legislature, a New York state prisons' inspector, a US commissioner of loans, an alderman, and also a director of the Manhattan Bank and president of City Bank. He died and was buried in New York in 1828 in a Reformed Dutch Church cemetery, but leading Augustans in the 20th century became concerned about his grave being neglected. His remains were exhumed and buried in the cemetery of St. Paul's Episcopal Church in 1976. (Below, courtesy the *Augusta Chronicle*.)

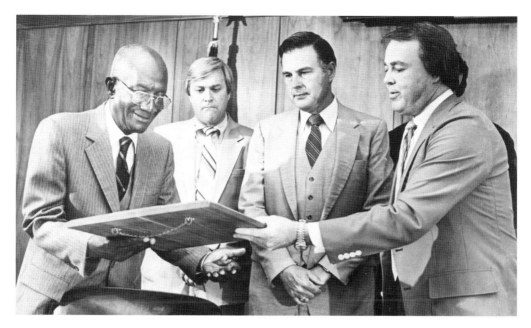

Richard A. "Papa" Dent

Richard Dent, brother of August city councilman B.L. Dent, was the first African American citizen elected to the Georgia General Assembly from Richmond County. He also became the first black Georgian since Reconstruction to chair a Georgia House Committee when Speaker Thomas B. Murphy appointed Dent as chairman of the House Committee on Human Relations and Aging in 1975. He died in 1982 at age 77. Pictured from left to right are Dent, Harold Smith, Travis Barnes, and Bill Hiers. (Photograph by Judy Ondrey; courtesy the *Augusta Chronicle*.)

Benjamin Linton "B.L." Dent

In 1965, Benjamin Linton Dent, better known as "B.L.," took the oath of office and became the first black elected official of any city government in Georgia since Reconstruction. The native Augustan became the owner of a furniture store, which was one of the first places in Augusta to sell 78 rpm blues records. The store became a popular restaurant known as B.L.'s. (Photograph by Judy Ondrey; courtesy the *Augusta Chronicle*.)

Bob Young

Young, shown with his wife, Gwen, first became known to most Augustans as the assistant news reporter for WBBQ radio station in North Augusta. He had already served with the Armed Forces Network in Vietnam. His work at WBBQ led him to become a news anchor with WJBF television station, then he became mayor of Augusta for six years. He served as regional director, and later as an assistant deputy secretary, for the US Department of Housing and Urban Development before becoming president and chief executive officer of Southeastern Natural Sciences Academy, a nonprofit research and educational institution that also operates Phinizy Swamp Nature Park. (Photograph by Margaret Sellers; courtesy the *Augusta Chronicle*.)

Larry Sconyers

His parents in 1956 created Sconyers' Bar-B-Que, but Larry took it to higher levels by building a two-story log cabin restaurant and serving his barbecue on the White House lawn during US president Jimmy Carter's administration. He became the first mayor of Augusta's consolidated city-county governments. Larry's restaurant has hosted many celebrities, including Burt Reynolds and Sally Fields. (Photograph by Jeff Barnes; courtesy the *Augusta Chronicle*.)

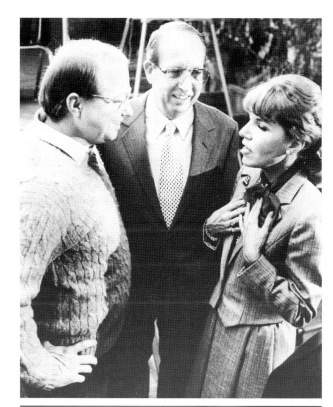

Thomas Allgood
Tom Allgood and his wife, Thelma ("Tee"), were killed in 2000 when their single-engine plane crashed as it was taking off from Daniel Field airport. Allgood, a prominent Augusta lawyer, shown at center with Wendell Johnston and Nan Connell, was elected to the Georgia Senate in 1976 to represent the 22nd District, which covered Augusta and part of Richmond County. He was named senate majority leader in 1981 and served until 1991. Gov. Zell Miller in 1993 appointed Allgood to the University of Georgia Board of Regents. (Photograph by Mark Phillips; courtesy the *Augusta Chronicle*.)

D. Douglas Barnard Jr.
A native Augustan, Barnard grew up with Carl Sanders as his best friend. He became executive secretary to Sanders when his friend was elected Georgia's governor. Barnard served in that role from 1963 to 1967 and also as a member of the Georgia Board of Transportation from 1966 to 1976. He became vice president of the Georgia Railroad Bank and Trust Company and served as a member of the US House of Representatives, representing Georgia's 10th District, which included Augusta from 1977 to 1993. (Courtesy the *Augusta Chronicle*.)

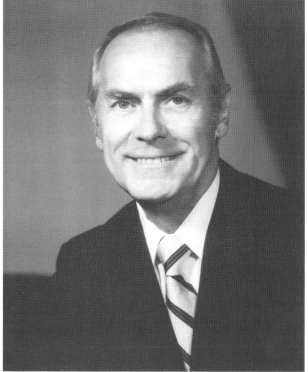

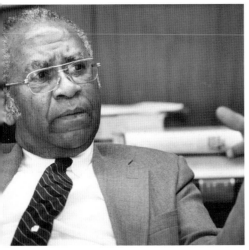

John H. "Jack" Ruffin Jr.

Ruffin, born in Waynesboro, Georgia, was educated in Burke County's segregated schools. He earned a law degree from Howard University in Washington, DC, and became the plaintiff's counsel in the 1964 class-action suit *Acree v. Richmond County Board of Education*, which brought about court-ordered desegregation and supervision of district schools. He became the first black member of the Augusta Bar Association and the first black Augusta Judicial Circuit superior court judge. In 1994, Gov. Zell Miller appointed him to the Georgia Court of Appeals. He became the first African American to serve as that court's chief judge in 2005 and 2006. His name is on the new Richmond County judicial center on Walton Way. (Photograph by Matthew Craig; courtesy the *Augusta Chronicle*.)

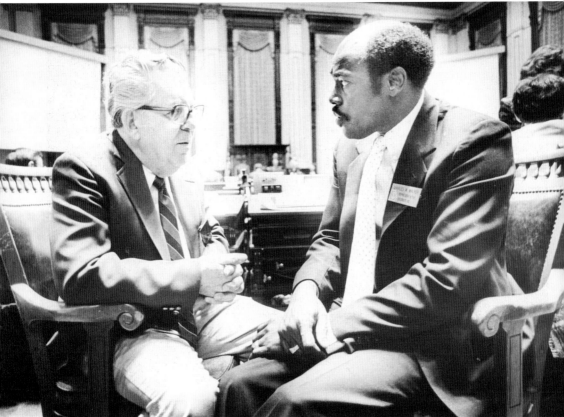

Michael J. Padgett

Padgett, a World War II–decorated veteran, shown at left with Charles Walker, served eight years on the Richmond County Commission, including as chairman. He served six years in the Georgia Senate, including as floor leader under Gov. Lester Maddox. He served 16 years in the Georgia House of Representatives and served 14 years as chairman of the Richmond County Legislative Delegation. Padgett owned Padgett Insurance & Realty. Mike Padgett Highway was named for him in 1995. (Courtesy the *Augusta Chronicle*.)

Carrie Mays
The owner of Mays Funeral Home in Augusta and the mother of former city councilman and former Richmond County commission chairman William "Willie" H. Mays III became the first female elected to the Augusta City Council and the first African American woman in the Southeast to serve in that capacity. She also was the first female secretary of the Georgia Democratic Party under Gov. George Busbee. (Photograph by Jimmy Watkins; courtesy the *Augusta Chronicle*.)

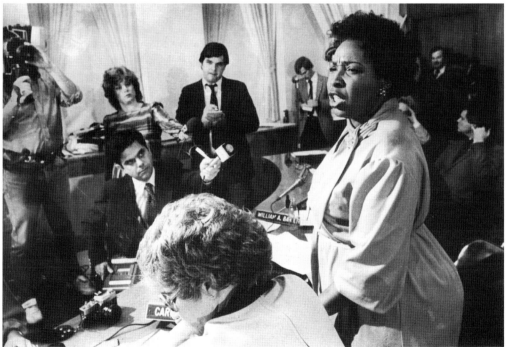

Margaret Armstrong
Business complexes Armstrong Galleria Phase I, completed in 1992, and Armstrong Galleria Phase II, completed in 2004, are named for Margaret Armstrong, an Augusta city councilwoman for more than a decade who is credited for helping kick-start revitalization efforts in the inner-city neighborhood. Armstrong, who also served on the Richmond County Planning Commission and the Laney-Walker Neighborhood Association, in 2002 was honored by the Martin Luther King Memorial CSRA Observance Committee with its MLK Life and Legacy Award for her dedication to public service and the community. (Photograph by Lannis Waters; courtesy the *Augusta Chronicle*.)

Carl Edward Sanders

Sanders, shown here with son, Carl Edwards Sanders Jr., was the only native Augustan to become governor of Georgia in the 20th century. He did many good things for Augusta as governor, including developing Augusta State University (now GRU Summerville) into a four-year college and bringing about the state's public broadcasting system. Georgia PBS station WCES in Wrens bears his initials. At right, Sanders and his son pose in front Georgia's capitol building. Below, he and his son; wife, Betty; and daughter, Betty Foy are being cheered by thousands along Broad Street on September 24, 1962. Sanders achieved success early by becoming president of his freshman class at Richmond Academy in Augusta. (Both, courtesy the *Augusta Chronicle*.)

Lewis A. "Pop" Newman
Newman, shown at center with Billy Calhoun (left) and Sam Maguire, owned White House Cleaners laundries. He served as Augusta's first full-time mayor and stayed elected to that leadership for nine years. The Newman Tennis Center on Wrightsboro Road is named for him. He was one of Georgia's top-ranked high school tennis players. He also led the I.M. Pei renovation of Broad Street. He and his wife, Quida ("Teeny"), were married 71 years until her death in 2013. (Courtesy the *Augusta Chronicle*.)

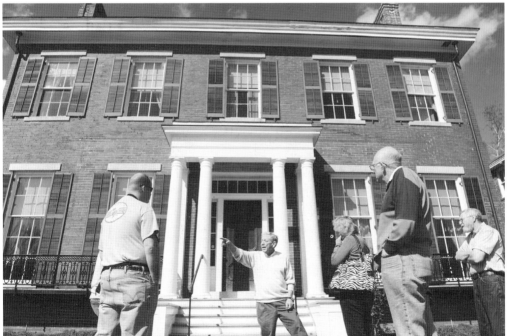

Thomas Woodrow Wilson
The 28th president of the United States spent his growing-up years living in Augusta, from 1860 to 1870, which included the Civil War years. It is said the horrors of the war led him to fight for the creation of the League of Nations. His father was pastor of the First Presbyterian Church at Seventh and Telfair Streets. Joe Vignati is shown conducting a tour of Wilson's boyhood home, which can be visited. (Photograph by Jackie Ricciardi; courtesy the *Augusta Chronicle*.)

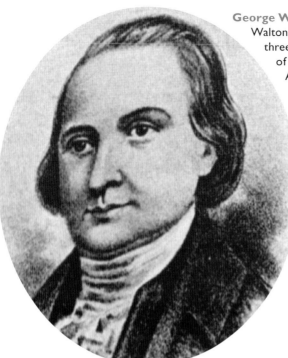

George Walton

Walton was 26 years old when he became one of three signers from Georgia on the Declaration of Independence. He had two homes in Augusta, one of which, Meadow Garden, is open to the public. He served as governor of Georgia, a superior court judge, chief justice of the Georgia Supreme Court, and US senator representing Georgia. He is the namesake of the main Augusta traffic artery Walton Way. (Courtesy the *Augusta Chronicle*.)

Lyman Hall

The remains of both Hall, another Declaration of Independence signer from Georgia, and George Walton are buried beneath the Signers' Monument on Greene Street in front of the municipal building. Hall was a physician who practiced in Charleston, South Carolina. He moved to Georgia, where he also became one of the state's early governors. He bought Shell Bluff Plantation in Burke County after the war and died there. In 1848, his remains were moved to Augusta when the Signers' Monument was built. (Courtesy the *Augusta Chronicle*.)

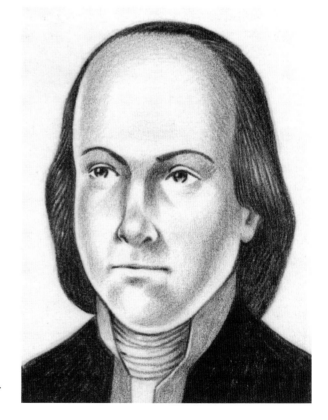

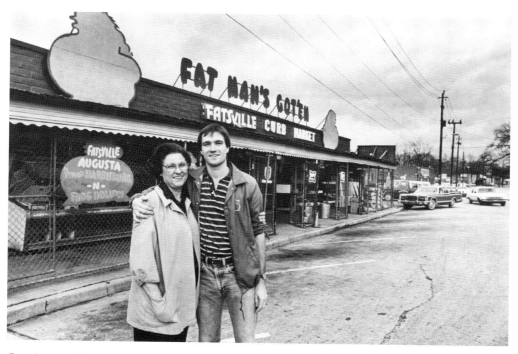

Carolyn and Brad Usry

Carolyn Usry, shown here with her son Brad, joined her husband, Horace, in creating one of Augusta's best known and most successful retail ventures, Fat Man's Forest, which capitalized on good Southern food and event-themed merchandise, especially during the Halloween, Christmas, and wedding seasons. Carolyn also became one of Augusta's most popular city council members, serving four terms. She served as president of the Augusta Convention & Visitors Bureau and was a member of the Aviation Commission and the Augusta-Richmond County Coliseum Authority. (Photograph by Judy Ondrey; courtesy the *Augusta Chronicle*.)

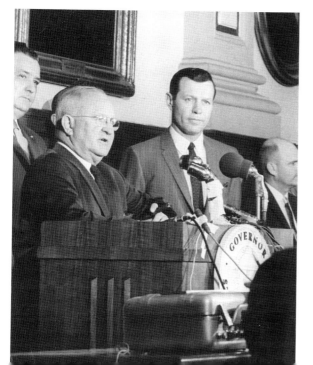

Roy V. Harris

Roy Vincent Harris, pictured at left with Augusta native and Georgia governor Carl Edward Sanders, became the powerful Speaker of the House of the Georgia General Assembly from 1937 to 1940 and 1943 to 1946, becoming known as a kingmaker. He served on the Georgia Board of Regents from 1951 to 1973. He was an avid segregationist but, ironically, became the city attorney for Ed McIntyre, Augusta's first African American mayor. Harris died in 1985 at age 90. (Courtesy the *Augusta Chronicle*.)

65

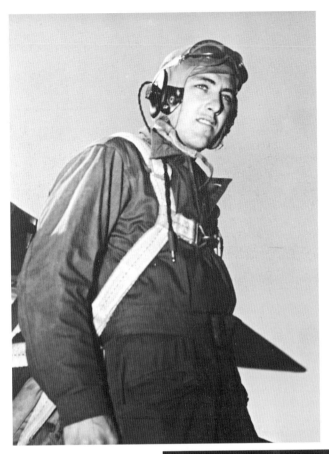

Jack Connell
One of the best-known gathering places for area politicians in Augusta has been the Sandwich City restaurant, thanks to owner Jack Connell being such a great businessman and politician. He served with the US Army Air Corps during World War II and flew 79 missions as a bombardier over Europe. He was elected to the Augusta City Council in 1959 and the Georgia House of Representatives in 1969, serving 34 years. He was elected speaker pro tempore of the House in 1977, a position he held for 26 years, making him the longest serving speaker pro tempore, both in Georgia and the United States. (Courtesy the *Augusta Chronicle*.)

Jimmy Lester
The legacy of Georgia state senator Lester, shown at right with Tom Allgood, may be one simple bill that continues to save lives throughout the nation. Lester knew of a terrible accident involving family friends that happened in the rain. So he drafted a bill saying that everyone in Georgia by law had to turn on his or her headlights when it rained or face a fine. Georgia was the first state to adopt such a law. All 50 states have now adopted similar legislation. (Photograph by Chuck Bigger; courtesy the *Augusta Chronicle*.)

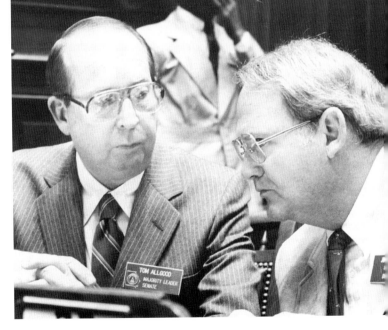

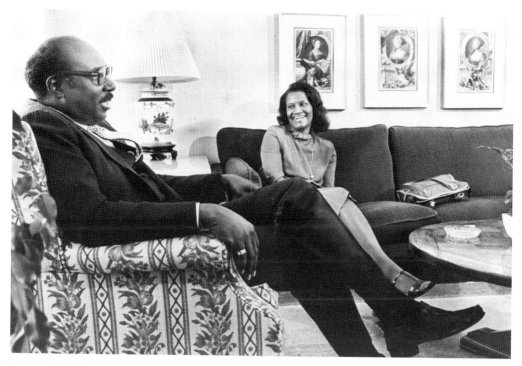

Edward M. McIntyre

McIntyre, shown with his wife, Juanita, was vice president of Pilgrim Health and Life Insurance Company for 17 years. He was also Richmond County's first black commissioner, Augusta's first black mayor, and founder of the Georgia Association of Black Elected Officials. McIntyre, while serving as mayor, was arrested and convicted of bribery and extortion charges and sentenced to five years in federal prison. He was released after 12 months and ran for mayor of the consolidated Augusta government twice, losing by only 1,459 votes in a 2002 runoff against Mayor Bob Young. (Photograph by Lannis Waters; courtesy the *Augusta Chronicle*.)

Eugene Holley

Holley was an Augusta lawyer who became a powerful and wealthy Georgia politician. He lost his fortunes when sulfur got in his Arab oil wells. He changed the face of downtown Augusta as chairman of the Coliseum Authority and built Augusta's first skyscraper hotel (now the Ramada). His former office on top of the Lamar Building, which he once owned, is often referred to as the "glass toaster." (Photograph by Jim King; courtesy the *Augusta Chronicle*.)

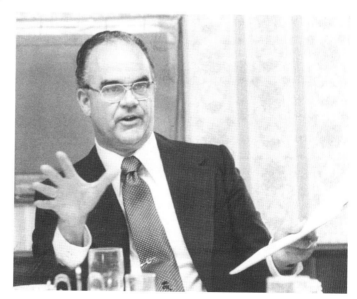

Strom Thurmond

US senator Strom Thurmond of Edgefield, South Carolina, is seen at right center with his wife, Nancy, at far right. He helped Augusta almost as much as any US congress member from Georgia. He frequently was seen in the Augusta area, usually shaking hands and smiling. (Photograph by Mark Phillips; courtesy the *Augusta Chronicle*.)

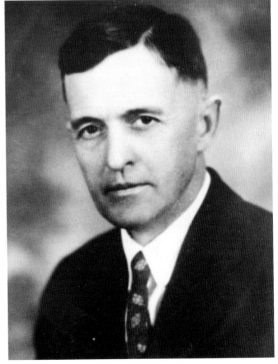

William B. Bell

Augusta's largest performing venue for more than 35 years was Bell Auditorium, which is still in heavy use for concerts, trade shows, and other events. The city auditorium, which cost $440,000, was dedicated on March 31, 1940, with 3,560 seats in the main section and 929 in the rear music hall section. It was originally called Municipal Auditorium but was renamed the William B. Bell Auditorium in 1951 in honor of the progressive Augusta mayor. (Courtesy the *Augusta Chronicle*.)

CHAPTER FIVE

Stars of Stages and Screens

One can only imagine what it was like for Augustans in the late 1800s to sit in darkened theaters and watch the "magic screens" as moving pictures unfolded before their eyes. And, God forbid if any of those folks had the vision that one day they could watch those moving pictures in the privacy of their homes, on computers and on giant, flat screens mounted to the wall.

The first formal, organized entertainment in Augusta apparently happened when a music teacher named Claude Simon came up from Savannah and offered to perform at the house of Belgium emigrant Emanuel Wambersie in May 1787. The purpose of Simon's concert was to raise money for instruments for his music students. The ties to his mother country of Great Britain apparently were still strong more than a decade after the American Revolution, because the admission for the concert was 10 shillings.

Over the years, Augusta saw many amazing entertainment offerings, including the appearance of the first elephant ever seen in America. It did not take long before Augusta became part of an artistic triangle for performers from New York and Philadelphia who came down the coast to Charleston, then headed on to Savannah before coming up to Augusta and heading back north.

John Wilkes Booth, the talented actor and killer of Pres. Abraham Lincoln, apparently did not come to Augusta to perform, but his tragedian father, Junius Booth, performed Shakespeare's plays in Augusta in the early 1800s, as did Booth's brothers Junius Booth Jr. and Edwin Booth.

Many of the nation's most famous early celebrities, including Ethel Barrymore, George M. Cohan, Buffalo Bill Cody, Annie Oakley, Anna Pavlowa, Charlie Chaplin, Tom Mix, Lillian Russell, Sarah Bernhardt, and more, found their way to perform before Augusta audiences.

When the 20th century came along, almost all of its stars came to entertain local fans, including the greatest of both black and white entertainers: Louis Armstrong, Ethel Waters, Earl "Fatha" Hines, Duke Ellington, Louis Jordan, Joe "King" Oliver, Tiny Bradshaw, Ray Charles, Little Richard, Otis Redding, Elvis Presley, Eddy Arnold, Jerry Lee Lewis, Liberace, Roy Orbison, Marty Robbins, Johnny Cash, George Jones, and others.

Along the way, Augusta began creating stars for the rest of the world; stars who had either been born in Augusta or who had their show business breaks here. These included Brenda Lee, Amy Grant, Hulk Hogan, James Brown, Jessye Norman, Sharon Jones, Flo Carter, Jim Nabors, the Swanee Quintet, the Dregs, Georgia Prophets, Mickey Murray, Faith Prince, Hunter Foster, Leon Everette, Terri Gibbs, Ginny Wright, Nell McBride, the Lewis Family, Jeff and Sheri Easter, and more. Movie superstars Rip Torn and Robert Duvall performed with the Augusta Players, as did Tony Award–winner Sutton Foster.

Even today, Augusta keeps furnishing the world with world-class entertainers.

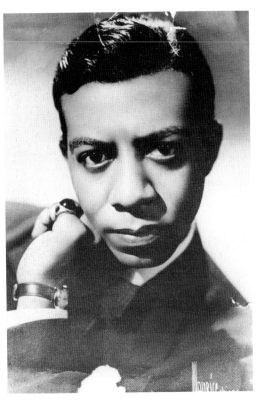

Arthur Lee Simpkins
Born in Hamburg, South Carolina, which no longer exists across the Savannah River from Augusta, Simpkins and his band, the Nighthawks, performed at Augusta's best white-society parties in the 1930s and 1940s. The former Georgia Railroad Bank and Trust Company porter became world famous for his recording of "Trees," a song set to the Joyce Kilmer poem. He spoke six languages and was the guest soloist at the 1952 National Democratic Convention in Chicago. (Courtesy the *Augusta Chronicle*.)

Walter Clarence "Dub" Taylor Jr.
Taylor was often photographed wearing the trademark Derby hat that he wore on the *Hee Haw* television comedy series. Taylor lived in Augusta from ages 5 to 13. His father was a cotton broker in the cotton exchange. He became a close friend of neighbor Ty Cobb Jr., the son of the baseball player. He appeared in more than 500 movies, including *Auntie Mame, Parrish, How the West Was Won, The Wild Bunch, No Time For Sergeants,* and *Bonnie & Clyde*. (Courtesy the Nashville Network Cable Network.)

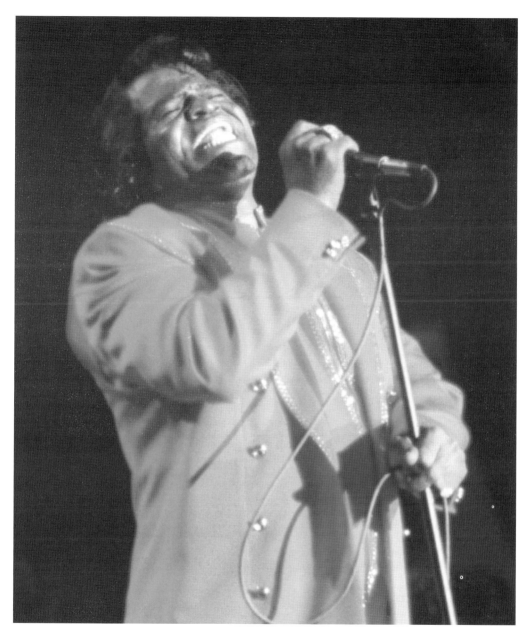

James Brown
He was "Soul Brother No. I," "the Godfather of Soul," and "the Hardest Working Man in Show Business" all rolled into one. Brown was born in rural Barnwell County, South Carolina, near Elko. His family moved to Augusta when he was five. Other than a few years living in Toccoa, Georgia, and upper New York, Brown spent most of his life calling the Augusta area his home. He recorded several of his best-selling albums and singles in Augusta and North Augusta. He was honored before his death by having Ninth Street in Augusta renamed James Brown Boulevard, having the Augusta-Richmond County Civic Center renamed James Brown Arena, and having a statue erected in the middle of the 800 block of Broad Street. His family hopes to one day open his ranch house in Beech Island, South Carolina, just outside Augusta, to the public. (Courtesy the *Augusta Chronicle*.)

Frank Miller

Miller started his show-business career in Augusta by handing out programs at the Grand Opera House. He built the Art Deco–themed Miller Theater on Broad Street, which opened February 26, 1940. The next year, Katharine Hepburn stopped by the theater on her way to Savannah to see the theater and have lunch with Miller. Stars who performed live in the Miller included Tallulah Bankhead, Alfred Lunt, Lynn Fontanne, Montgomery Cliff, Eddy Arnold, Gordon Scott, and the rock band Lynyrd Skynyrd. The popular movie *The Three Faces of Eve* had its world premiere at the Miller. (Courtesy the *Augusta Chronicle*.)

Señor José Andonegui

Andonegui was a violinist in the early 20th century who educated Augustans about classical music with his solo performances and orchestra. His infant son died in Augusta in 1911 when he was on tour, two brothers were killed in a Mexican uprising, and another son, a US Navy lieutenant, drowned in 1945 near Iwo Jima when his ship sunk during World War II. Andonegui died in 1941 in Mexico City. (Courtesy Augusta Museum of History.)

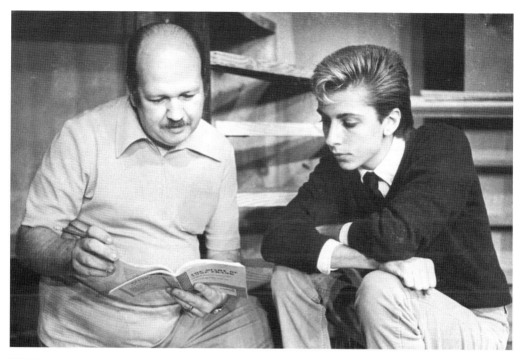

Rick Bracken

Bracken, pictured at left with Matthew Buzzell, was one of the best amateur actors and directors to get involved with Augusta plays. He especially was known for his work with children's productions. Bracken served in every position with the Augusta Players, including several terms as president. He also acted and directed with other play groups and won many acting awards. He was an Army veteran, a vice president of Miller Printing & Publishing Company, an editor of *Scene* magazine, and a president of the Civitan Club of Augusta. (Photograph by Drake White; courtesy the *Augusta Chronicle*.)

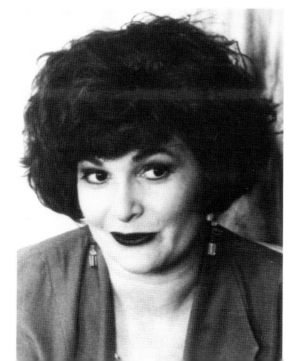

Faith Prince

Tony Award–winning actress Faith Prince was born to Keith and Gloria Prince in St. Joseph's Hospital (now Trinity) in Augusta on August 6, 1957. She was raised in Lynchburg, Virginia, but returned often to her native city to visit her grandparents Cleon and Ruth Prince. She won a 1992 Tony Award as Best Actress in a Musical for playing Miss Adelaide in *Guys and Dolls*. She also was nominated in 2001 for another Tony for her starring role in the revival of *Bells Are Ringing*. Her television credits include recurring roles on *Spin City* and *Now And Again*. (Courtesy the *Augusta Chronicle*.)

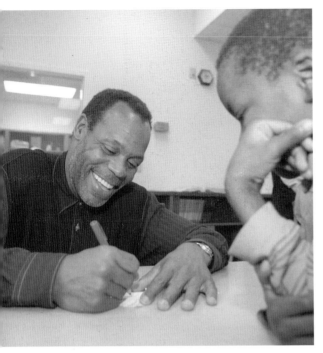

Danny Glover

Carrie Hunley, a native of Louisville, Georgia, had no way of knowing when she graduated in the class of 1942 at Augusta's Paine College that she would have a son who would become one of the most famous actors in the world. Hunley moved to New York where she met James Glover Sr. They moved to San Francisco where their son Danny was born. Danny Glover spent many childhood summers on his grandparents' farm south of Augusta off US Highway 1. He went on to star in such classic movies as *The Color Purple*, *Witness*, *Places in the Heart* and the Lethal Weapon series. He established a scholarship in his mother's name at Paine College. Here, Danny signs an autograph for Lamar Elementary School student Kentae Green after speaking at the school. (Photograph by Matthew Craig, courtesy the *Augusta Chronicle*.)

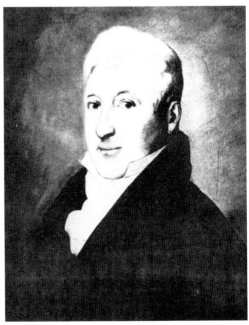

Emanuel Wambersie

Fenton Martin and her husband, Richard Pacelle, hold a portrait of Martin's Belgium-born ancestor Emanuel Wambersie at his house near the Savannah River. Wambersie hosted Augusta's first organized concert on May 1, 1787, during which Claude Simon performed selections on a pianoforte. Wambersie moved to Savannah and married Ann Phoebe Charlton, a first cousin of Francis Scott Key. He became a judge and a US ambassador to Rotterdam. (Photograph by Don Rhodes; drawing courtesy Gemeente Rotterdam.)

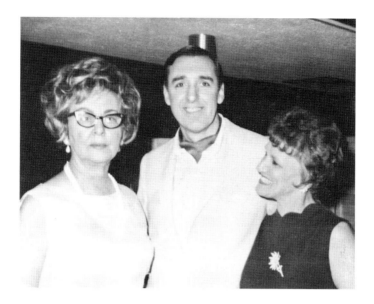

Flo Carter

One of the most entertaining artists for more than 50 years in Augusta has been the great Flo Carter, shown at right with Dot Huff and Jim Nabors. She and her band, the Rockets, which included her husband, Don Carter, on drums, were rockabilly pioneers on the local scene. She was one of the first performers when WJBF television station went on the air in 1953, and she sang with Jimmy Nabors live on the *Today In Dixie* variety show. (He later became famous as television character Gomer Pyle.) Carter sang blues and classic standards in Augusta's best supper clubs, with her audience sometimes including the White House press corps covering vacationing Pres. Dwight D. Eisenhower. She and her country gospel band, the Sounds of Joy, which included her guitar-playing mother, Ada Collins ("Groovy Granny"), has sung in New York City's Central Park and on the Mall in Washington, DC. The band in recent years has included her daughters Donna, Cookie, and Toni. She also has performed with the Augusta Concert Band and the Augusta Symphony and was honored in 1997 by the Greater Augusta Arts Council as Artist of the Year. In the image below, she is seen with Jerry Morin, commander of North Augusta's Jesse C. Lynch Memorial American Legion Post 71. (Above, courtesy Flo Carter; below, photograph by Sara Caldwell, courtesy the *Augusta Chronicle*.)

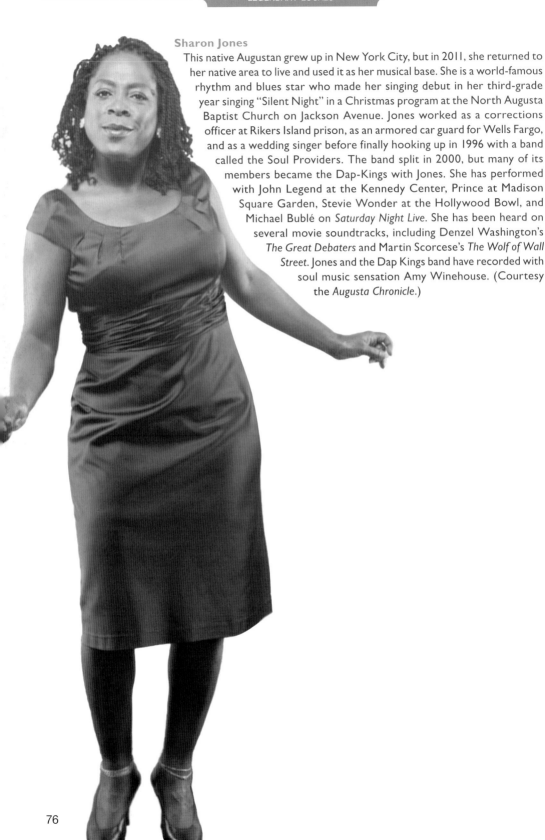

Sharon Jones

This native Augustan grew up in New York City, but in 2011, she returned to her native area to live and used it as her musical base. She is a world-famous rhythm and blues star who made her singing debut in her third-grade year singing "Silent Night" in a Christmas program at the North Augusta Baptist Church on Jackson Avenue. Jones worked as a corrections officer at Rikers Island prison, as an armored car guard for Wells Fargo, and as a wedding singer before finally hooking up in 1996 with a band called the Soul Providers. The band split in 2000, but many of its members became the Dap-Kings with Jones. She has performed with John Legend at the Kennedy Center, Prince at Madison Square Garden, Stevie Wonder at the Hollywood Bowl, and Michael Bublé on *Saturday Night Live*. She has been heard on several movie soundtracks, including Denzel Washington's *The Great Debaters* and Martin Scorcese's *The Wolf of Wall Street*. Jones and the Dap Kings band have recorded with soul music sensation Amy Winehouse. (Courtesy the *Augusta Chronicle*.)

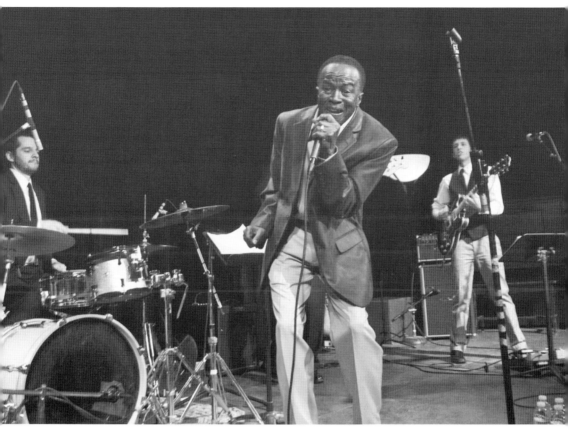

Mickey Murray

Murray, who retired from Georgia Pacific in Augusta in 2007, has been best known in recent years for singing in the choir of Old Storm Branch Baptist Church in North Augusta and at parties, weddings, and family gatherings. But his name and fame were brought back to public life with Secret Stash Records in Minneapolis, Minnesota, when it reissued Murray's 1970 vinyl album, *People Are Together*, with new packaging. In the late 1960s, Murray was one of the nation's best-known soul music singers, with his 1967 recording of "Shout Bamalama" selling a million copies. His fans included "the Godfather of Soul" himself, James Brown. He recorded on the powerful King/Federal labels, opened shows for Aretha Franklin at Harlem's famed Apollo Theater, and toured with such hot rhythm and blues acts as Wilson Pickett, the Staple Singers, and the Isley Brothers. Murray and his brother Clarence started out singing gospel songs in Augusta and North Augusta. His brother became a lead vocalist with the legendary Swanee Quintet that is based in Augusta. Murray also sang with the Dixie Jubilaires, and he performed for about three years with the Augusta-based band Leroy Lloyd and the Swinging Dukes. (Courtesy the *Augusta Chronicle*.)

Jerry Harris
For several decades, Harris was one of Augusta's best-liked and most-talented entertainers. He is shown here on December 21, 1983, playing in the Eagle's Nest nightclub atop the Augusta Hilton (later the Landmark and Ramada Hotels). He was the pianist at the Lenox Theater and played at the Ship Ahoy restaurant on Broad Street for many years. His sister Rose Sanders Creque was opera star Jessye Norman's first formal voice coach, and his nephew Tim Sanders now plays in the popular PlayBack band. (Photograph by Shaun Stanley; courtesy the *Augusta Chronicle*.)

Emily Remington
One person who did much for Augusta's classical music scene in the 20th century was Emily Remington, who founded the modern version of the Augusta Choral Society in 1951. George Frederic Handel's "Messiah" was chosen for the group's debut on December 9, 1951, in Post Theater No. 3 at then Camp Gordon. One of her vocal students was future opera star Jessye Norman, who was accompanied by pianist Remington in the music hall section of Bell Auditorium on February 1, 1970. (Photograph by Henry Greene; courtesy the *Augusta Chronicle*.)

Terri Gibbs

Born with sight in Miami, Florida, Teresa Fay Gibbs Daughtry became blind due to an incubator accident. That never stopped her from achieving great success. She grew up singing gospel and country music in the Augusta area and graduated from Butler High in 1972. The school in 1983 named its new music complex after her. Gibbs's first MCA Records single, "Somebody's Knockin'," became an international music sensation in 1981. That same year, she became the first artist to win the Country Music Association's Horizon Award for upcoming performers. She also won the Academy of Country Music's Best New Female Vocalist Award. She appeared on major television shows such as *Solid Gold*, *American Bandstand*, and *The Barbara Mandrell Show*. (Photograph by Judy Ondrey; courtesy the *Augusta Chronicle*.)

Thelma "Butterfly" McQueen

McQueen spent her young years living in Augusta and moved to New York when she was 13 and got into acting. It was a friend who suggested she try out for the role of Prissy, the slave girl in *Gone With the Wind*. She went on to appear in several major movies, including *Cabin in the Sky*, *Mildred Pierce*, and *Mosquito Coast*, and she costarred in *Beulah*, one of the first television shows to feature black actors. She spent most of her winters living in Augusta and one time taught drama for the city's recreation department. She died in 1995 as a result of a fire at her Augusta home. (Photograph by Eric Olig; courtesy the *Augusta Chronicle*.)

Larry Jon Wilson
For more than four decades, this Augusta-area resident was known for his distinctive deep voice, great guitar playing, and colorful, story-telling songs. He was signed to Monument Records in Nashville in 1973 and became a "singer's singer" admired by legends like Willie Nelson, Waylon Jennings, Tammy Wynette, Kris Kristofferson, Larry Gatlin, and Mickey Newbury. It was his voice that was heard on the Turner South cable television network announcing upcoming programs, and he hosted Georgia Public Television's *Georgia Back Road* series. (Photograph by Nelson Harris; courtesy the *Augusta Chronicle*.)

Lady Antebellum
One of the fastest-rising country music acts has been Lady Antebellum, consisting of Hillary Scott, Charles Kelley (center), and Dave Haywood (right). Haywood and Kelley met at Riverside Middle School in Evans, Georgia, outside Augusta, and became friends. They continued their friendship at Lakeside High (class of 2000); Haywood was on the tennis team and Kelley was on the golf team. They graduated from the University of Georgia and moved to Nashville in February 2006, where they met Scott and formed Lady Antebellum. The trio's name comes from a promotional photograph shoot during which they were wearing Civil War–era costumes. (Photograph by Sara Caldwell; courtesy the *Augusta Chronicle*.)

Ed Turner

Turner's family moved from Spartanburg, South Carolina, to Augusta in 1955 and opened a piano business, Turner Music House, on Walton Way. His first live rock experience came in 1971 when seeing Lee Michaels ("Do You Know What I Mean") playing in Columbia, South Carolina. Over the years, Turner (pictured standing, third from the left) has played keyboards, sung solo and with bands, written about music, and hosted his popular *Mad Music Asylum* radio program. His Beatles's tribute band, No. 9, has sold out Augusta's Imperial Theatre more times than any other act in the Imperial's nearly 100-year history. (Photograph by Sara Caldwell; courtesy the *Augusta Chronicle*.)

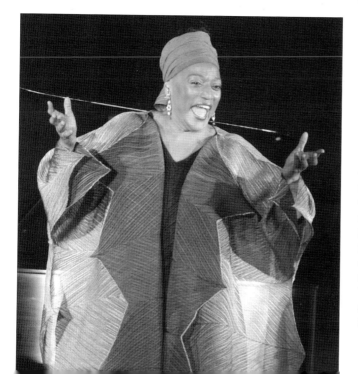

Jessye Norman

Norman grew up at 1444 Forest Avenue in Augusta listening to Saturday afternoon broadcasts of the Metropolitan Opera while cleaning her family's house. She won her first talent contest singing in nearby Mount Calvary Baptist Church, where her father was superintendent of the Sunday school classes. She sang for Queen Elizabeth II on her 60th birthday, at Pres. Ronald Reagan's 1985 inauguration, in Paris for the 200th anniversary of Bastille Day, and at the funeral of Jacqueline Kennedy Onassis. The amphitheater at Riverwalk Augusta is named in her honor. (Courtesy the *Augusta Chronicle*.)

Brenda Lee

At 11 years old, Brenda Lee was "discovered" in February 1956 by Grand Ole Opry star Red Foley in Augusta's Bell Auditorium, and she was invited to appear on Foley's nationally televised *Ozark Jubilee* show. As a reward, Brenda's parents took her back to Bell Auditorium the following month in March to see a rising new rockabilly singer named Elvis Presley. Lee and Presley met backstage and became lifelong friends. WRDW program director Sammy Barton suggested that Lee change her name from Brenda Mae Tarpley to Brenda Lee when she started singing live on the North Augusta station each day. She eventually went from singing to Augusta-area audiences to performing for Queen Elizabeth II. She has sold more than 100 million recordings, including such giant hits as "I'm Sorry," "Sweet Nothin's," "Break It To Me Gently," "All Alone Am I," "As Usual," "Am I Losing You?," "Jingle Bell Rock," and "Rockin' Around The Christmas Tree." She was inducted into the Georgia Music Hall of Fame, the Country Music Association Hall of Fame, and the Rock and Roll Hall of Fame. Below, Brenda Lee is shown with Georgia Gov. Joe Frank Harris. (Both, courtesy the *Augusta Chronicle*.)

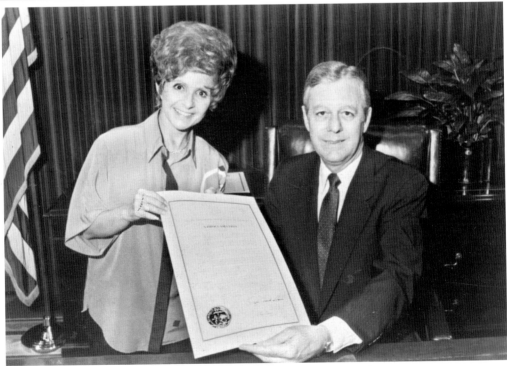

The Lewis Family

For more than 50 years, "America's First Family of Bluegrass and Gospel Music" was seen performing on Augusta's WJBF television station. The core group consisted of Roy "Pop" Lewis; his daughters, Polly, Janis and Miggie; his sons Wallace and Little Roy; and his grandsons Travis and Lewis. Their performances took them across the nation repeatedly and outside the United States as well. The group, based in Lincolnton, Georgia, outside Augusta, recorded scores of albums and performed at thousands of bluegrass and gospel music shows, including at New York's Lincoln Center and the Smithsonian's Baird Auditorium. They were inducted into the Georgia Music Hall of Fame. Pop Lewis, his daughter Polly Williamson Copsey, and his son Little Roy Lewis were also inducted into the Southern Gospel Music Hall of Fame at Dollywood. Their fans included Mamie Eisenhower, Elvis Presley, and Chet Atkins, among others. The group split up due to aging and dying members; it reformed into two groups. Little Roy joined Lizzy Long, also of Lincolnton, forming the Little Roy and Lizzy Show. Pop and Pauline Lewis's daughter Janis Phillips, her son Lewis Phillips, and her nephew Travis Lewis (son of former group member Wallace Lewis), formed the Lewis Tradition. Pictured above, from left to right, are Janis Lewis Phillips, Little Roy Lewis, Polly Lewis Copsey, Wallace Lewis, Miggie Lewis, and Roy "Pop" Lewis. Below are, from left to right, Little Roy Lewis, Travis Lewis, Miggie Lewis, Polly Lewis Copsey, Janis Lewis Phillips, and Lewis Phillips, with Pop Lewis in the rocking chair. (Both, courtesy the Lewis family.)

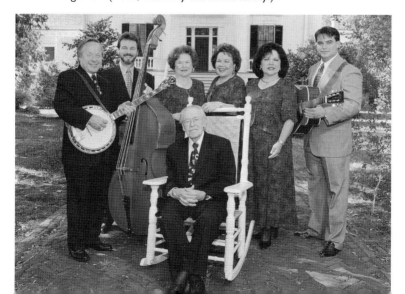

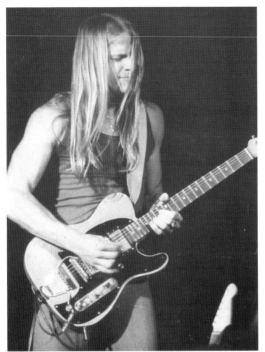

Steve Morse
Morse and his high school friend Andy West, from the Academy of Richmond County in Augusta, cofounded the band Dixie Grit, which evolved into Dixie Dregs, which evolved into just the Dregs. The band recorded several albums for Capricorn Records based in Macon, Georgia. Morse was named "Best Overall Guitarist" five times in *Guitar Player* magazine's readers' poll and toured with the bands Kansas and Deep Purple. (Photograph by Phillip Powell; courtesy the *Augusta Chronicle*.)

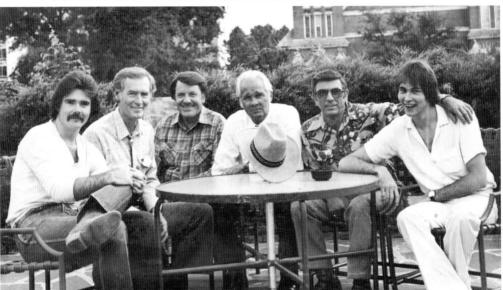

Ed Hurt
As the master of ceremonies for bluegrass music festivals, Hurt introduced many famous musicians, including fellow Kentuckian Bill Monroe, the "Father of Bluegrass Music." Hurt, who grew up in Harlan, Kentucky, became the host of huge festivals in Lavonia, Georgia, and Union Grove, North Carolina, the latter of which drew a crowd of 275,000 at its peak. The clerk and fleet transport dispatcher for Boardman Oil Company also played fiddle, mandolin, and guitar in several of his own Augusta bands, such as the Cross Country Bluegrass Cutups. Pictured from left to right are Larry Reese, Charles Reese, George Pritchard, Fargo Pope, Ed Hurt, and John Lamb. (Courtesy the *Augusta Chronicle*.)

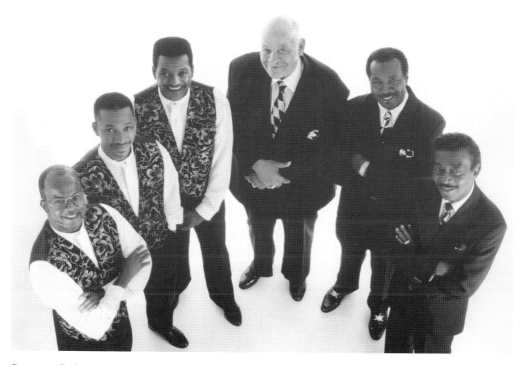

Swanee Quintet

This legendary gospel music group based in Augusta began as a trio, with Charlie Barnwell, Rufus Washington, and William Crawford singing together in Georgia and South Carolina in 1944. They soon added James "Big Red" Anderson and Rubin Willingham to become the Swanee Quintet in 1946. They were a favorite group with Apollo Theater fans and often performed shows with James Brown. They have traveled to almost every state, playing at venues such as Carnegie Hall and Madison Square Garden. Though the number of members has changed over the years, the group always retained the name "quintet." (Courtesy the Swanee Quintet.)

Dick Flood, "Okefenokee Joe"

One of the best known Augusta-area residents in recent years has been television personality, swamp-wise expert, and recording artist Okefenokee Joe, who was the Okefenokee Swamp's animal curator and only resident for eight years. His videos about snakes have been used as a teaching tool in hundreds of schools and his highly rated Georgia Public Broadcasting System television specials have aired many times. He also was a recording artist for Monument Records in Nashville under his real name, Dick Flood, and wrote the hit single "Trouble's Back In Town," used by the Grand Ole Opry duo the Wilburn Brothers as the theme song for their syndicated television show. (Photograph by Don Rhodes.)

Carey Murdock
Born in Augusta and raised in North Augusta, Murdock is a talented singer and composer, who at the age of 25, completed his second tour of European countries in 2013 with 60 concerts in three months. He already has performed at the Bitter End in New York City and with his band at the Bluebird in Nashville. Here, he performs at the A Day in the Country Festival at Augusta's Riverfront Marina. (Photograph by Don Rhodes; courtesy the *Augusta Chronicle*.)

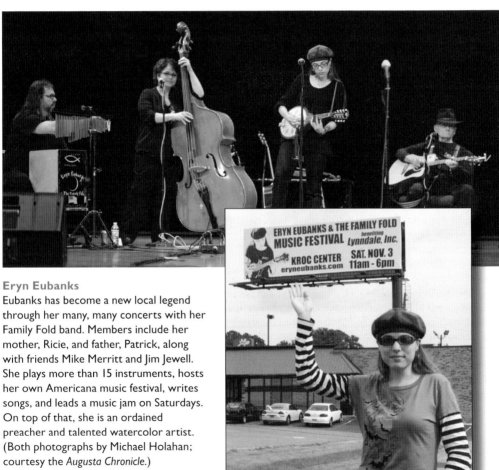

Eryn Eubanks
Eubanks has become a new local legend through her many, many concerts with her Family Fold band. Members include her mother, Ricie, and father, Patrick, along with friends Mike Merritt and Jim Jewell. She plays more than 15 instruments, hosts her own Americana music festival, writes songs, and leads a music jam on Saturdays. On top of that, she is an ordained preacher and talented watercolor artist. (Both photographs by Michael Holahan; courtesy the *Augusta Chronicle*.)

CHAPTER SIX

Authors and Memorable Media Folks

The oldest arts organization in Augusta is the Augusta Authors Club, founded in 1928 by Ruby Radford, Constance Lewis, and Lawton B. Evans.

"At that time, Dr. Evans had several books in print, I had one published and another scheduled for that year, while Constance's poetry still waited for printer's ink," Radford wrote in 1960 in recalling how the club started. "There has been a rare spirit of fellowship and encouragement in this club with no professional jealousy," she observed. "Everyone truly rejoices with others when they make the grade by getting a piece of work in print."

Authors and actors were among the first "celebrities" to visit Augusta and to become world famous while living in the Augusta area. There has been a Georgia Historical Commission marker in the 700 block of Broad Street honoring British author William Makepeace Thackeray, who visited Augusta in 1856 and spoke in the Masonic Hall, which stood at the marker's location.

Years before that appearance, native Augustan and lawyer Augustus Baldwin Longstreet in 1835 published what is widely regarded as Georgia's first important literary work: *Georgia Scenes, Characters, Incidents, Etc. in the First Half Century of the Republic.*

Throughout the years, Augusta produced many famous authors who called the city home, while others, such as Erskine Caldwell, Frank Yerby, and Paul Hemphill, didn't become famous until after they had left the Augusta area.

Some of Augusta's earliest best-known residents, other than politicians, have been writers and editors of the *Augusta Chronicle*, which has been in publication since 1785 when it made its debut as the *Augusta Gazette*.

The Georgia Historical Commission marker on Fifth Street near Ellis Street designates the spot where the newspaper was first published. The marker notes, "Among its editors prominent in public life were: Dennis Driscol (1804–11), who launched controversial journalism in Georgia; A.H. Pemberton (1825–36), first in State to urge nullification; N.S. Morse (1862–66) of Connecticut, whose diatribes against President Davis revealed Union sympathies which became undisguised upon the arrival of Federal troops after the surrender; Ambrose R. Wright (1866–72), Maj. Gen., C.S.A., elected to Congress from this District; Patrick Walsh (1873–99), Mayor of Augusta and U.S. Senator; Pleasant A. Stovall, Asst. Editor (1877–90), minister to Switzerland; and James Ryder Randall, Co-Editor (1877–87), famous poet who wrote *Maryland, My Maryland*."

Other media notables also emerged through the years either as popular columnists with the *Chronicle* and other print publications in the area or as popular radio, television, and film personalities.

Ruby Lorraine Radford
The Augusta Authors Club, which is the city's oldest arts organization, was cofounded by Radford, pictured at left in 1963 with Jean Cochran, in January 1928 along with Constance Lewis and Lawton Evans. Radford became the group's first secretary with Evans as its first president. Her literary output included more than 50 books and several hundred short stories, magazine serials, and plays. (Photograph by Breault Newsfoto; courtesy the *Augusta Chronicle*.)

Clifford "Baldy" Baldowski
This native Augustan, after earning a Bronze Star during World War II, became the editorial cartoonist for the *Augusta Chronicle* and began signing his *Chronicle* cartoons as "Baldy." He briefly went to work for the *Miami Herald* before joining the *Atlanta Constitution* in 1950. He created roughly 15,000 cartoons over the next 30 years. Baldowski retired in 1992 and died in 1999. Thousands of his cartoons are in the University of Georgia library collection. (Photograph by Don Rhodes.)

Robert "Flash" Gordon
While in high school, Gordon met popular WAUG announcer Mal "Your Pal" Cook in Augusta, who encouraged him to study at a good radio school. He graduated from the New York School of Announcing and Speech and began working for WAUG part time. Gordon managed James Brown–owned radio stations WRDW in Augusta, WJBE in Knoxville, and WEBB in Baltimore, and he owned two Pyramid Music record stores in Augusta. He also became the general manager of James Brown Arena. (Photograph by Eric Olig; courtesy the *Augusta Chronicle*.)

Karlton Howard
Howard, shown at right talking with Percy Griffin, hosted the *Parade of Quartets* gospel music show on Augusta's WJBF station for many years. The program has been on the air for more than 55 years. Howard worked in his family's upholstery business and in 1997 began serving as pastor of the Noah's Ark Missionary Baptist Church in Keysville, Georgia. His brother Wayne holds the state representative seat previously held by their father, Henry Howard. (Photograph by Margaret Moore; courtesy the *Augusta Chronicle*.)

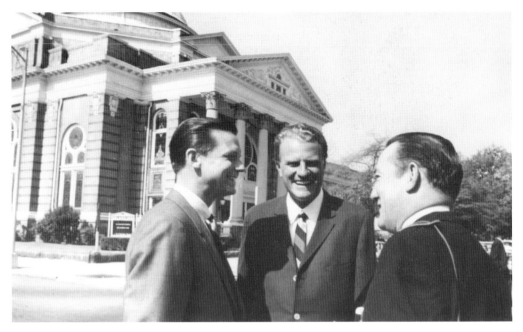

Jim Davis

Davis, shown at right with R.J. Robinson (left) and Billy Graham (center), died in 2013 at age 88. He was Augusta's Walter Cronkite. Davis was news director of television stations WRDW (CBS), WJBF (ABC), and WAGT (NBC), as well as the 6 and 11 p.m. anchor for daily newscasts for 35 years. He served aboard an amphibious gunboat in the US Navy in World War II, seeing duty in both the Atlantic and Pacific theaters. He was very active in many civic clubs and community endeavors. (Photograph by George Schaeffer; courtesy the *Augusta Chronicle*.)

"Bwana" John Radeck

Thousands of Augusta-area children who watched the early years of television station WJBF, which went on the air in 1953, came to know Radeck as the pith hat–wearing, jungle explorer "Bwana John." The talented artist painted the walls of the studio's basement for his show as well as the paintings of Native American chiefs shown in this photograph. Radeck, who also was an advertising sales manager, later became president and general manager of WJBF. He also managed a television station in Helena, Montana. (Photograph by Philip Powell, courtesy the *Augusta Chronicle*.)

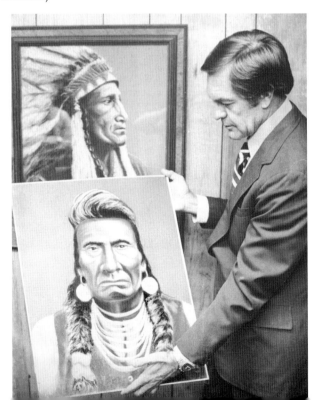

"Trooper" Terry Sams

Sams estimates that more than 100,000 boys and girls from around the Central Savannah River Area appeared on his *Trooper Terry Show* on Saturday mornings from 1961 to 1981 on Augusta's WJBF television station. His trademark slogan was, "Hey, kids, you better come running." One of the show's features was his "magic viewing screen." His first day working for WJBF in 1961 was as a Santa Claus helper. (Photograph by Jonathan Ernst; courtesy the *Augusta Chronicle*.)

George Fisher

Fisher was on his way to Florida for a job interview when he heard about an opening at WGAC-AM radio station in Augusta. He took the job and also helped put WAUG on the air. He briefly was with WBBQ, became co-owner of WBIA, and returned to WGAC in 1982. He was famous for "marching the kids off to school." Fisher, who died in 1995, was inducted into the Georgia Radio Hall of Fame. (Photograph by Eric Olig; courtesy the *Augusta Chronicle*.)

Earl Bell

This veteran newspaper journalist worked for the *Augusta Herald* and the *Augusta Chronicle* for about 50 years. He served as a sports editor and columnist, telegraph editor, and editorial writer. He also wrote one of the earliest science fiction novels, *Moon of Doom*, and coauthored *The Augusta Chronicle: Indomitable Voice of Dixie* with Kenneth C. Crabbe. He was a member of the Augusta Author's Club and Richmond County Historical Society. (Photograph by Morgan Fitz; courtesy the *Augusta Chronicle*.)

Louis C. Harris

One of the most colorful and influential newspaper people in Augusta was Harris, who rose from assistant circulation manager to becoming executive editor of the *Augusta Chronicle* and president of the Georgia Press Association (GPA). He was one of the first journalists in America invited to witness an atomic bomb explosion. He is shown at right in 1967 at the GPA's annual gathering with then-Georgia governor Lester Maddox. (Courtesy the *Augusta Chronicle*.)

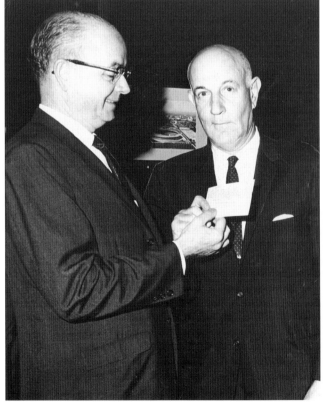

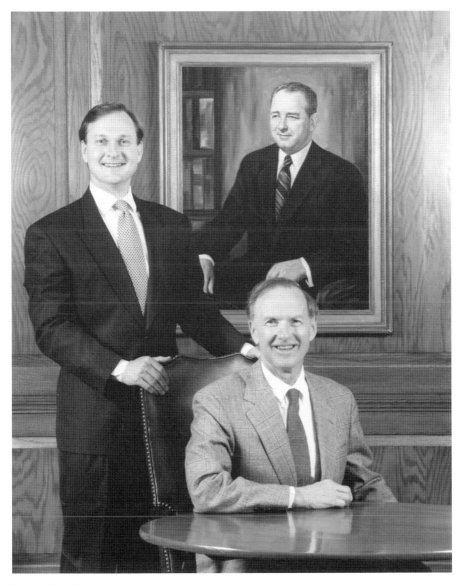

The Morris Family
The Morris family began its multimedia company when William S. Morris Jr. (shown in the painting) joined the *Augusta Chronicle* as a bookkeeper in 1929. He eventually became owner of the *Chronicle* and the afternoon daily *Augusta Herald*. William S. "Billy" Morris III (shown seated beside William S. "Will" Morris IV) became assistant to the president in 1956 on the eve of his 22nd birthday and in 1966 was named publisher of the Augusta newspapers and president of Southeastern Newspapers Corporation, successor of the Chronicle Publishing Company. Billy led the corporation to develop the multimedia businesses seen today across the nation and overseas, with daily and weekly newspapers, radio stations, book publishing, visitor publications, city magazines, equine interest publications, and other business endeavors, including the National Barrel Horse Association with its 22,000-plus members throughout the world. The family always has been very community oriented, including creating the Morris Museum of Art in 1992 on Augusta's Riverwalk, honoring Billy's parents and preserving classic artistic works by Southern artists or having Southern themes. (Courtesy Morris Communications Company.)

John Barnes

When Barnes came to Augusta in 1934 after studying chemistry and biology at Mercer University, his original goal was to get into medical school in Augusta. But a bout with tuberculosis changed his career path and he applied for a writing job with the *Augusta Chronicle*. He spent several years as city editor of the *Augusta Herald*, for which he daily wrote his popular "Our Town" column of personal observations. Here, he is being honored by his coworkers. (Courtesy the *Augusta Chronicle*.)

52

ADMIT ONE — $8.00

Retirement Party
For
Margaret Twiggs

Thursday, July 12, 1984
Augusta-Richmond County
CIVIC CENTER
Cocktails — 7 p.m. Dinner — 8 p.m.

Margaret Twiggs

One unusual form of entertainment in Augusta has been political roasts, especially a series of "Turkey Shoots" sponsored by the Sigma Delta Chi organization for professional journalists. This was the ticket for the retirement roast on July 12, 1984, in the civic center for Margaret Twiggs, a longtime writer for the *Augusta Herald* and the *Augusta Chronicle*. The roast emcee was Bob Young, who later became mayor of Augusta. (Courtesy Don Rhodes.)

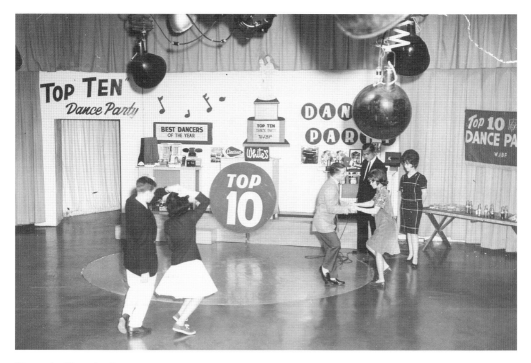

Georgia Cunningham

Cunningham, shown standing at far right with Carroll Ward, was only 19 when she first started working on the WJBF-TV Channel 6 show *Top Ten Dance Party*. She herself had been named the show's best dancer of the year. She has also lent her many talents to the Augusta Ballet, Augusta Players, Greater Augusta Arts Council, and Storyland Theatre. (Courtesy the *Augusta Chronicle*.)

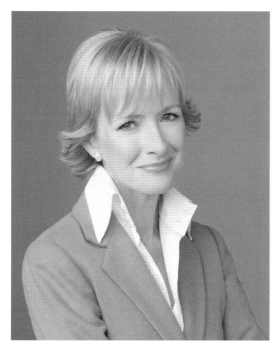

Judy Woodruff

Woodruff, a graduate of the Academy of Richmond County, served as an anchor and senior correspondent for the CNN cable television network for 12 years. Her journalism career started in Atlanta and led her to being a media star in the nation's capital. She was chief White House correspondent for NBC News from 1977 to 1982 and covered Washington for the *Today Show*. She left NBC for the PBS documentary series *Frontline with Judy Woodruff*. (Courtesy CNN.)

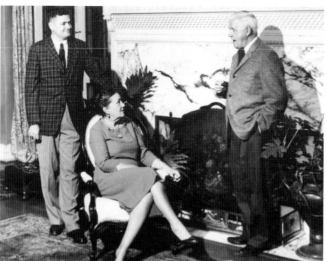

Edison Marshall
The first historical romance novel for Marshall, who served as a US Army public relations officer at Camp Hancock in Augusta, was *Benjamin Blake*, published in 1941. It was turned into the movie *Son of Fury*, starring Tyrone Power. Marshall wrote almost a novel a year before his death in 1967. Other Marshall novels include *The Lost Colony* and *Yankee Pasha*. He is shown here at right at home with his wife and son. (Breault Newsfoto by Morgan Fitz, courtesy the *Augusta Chronicle*.)

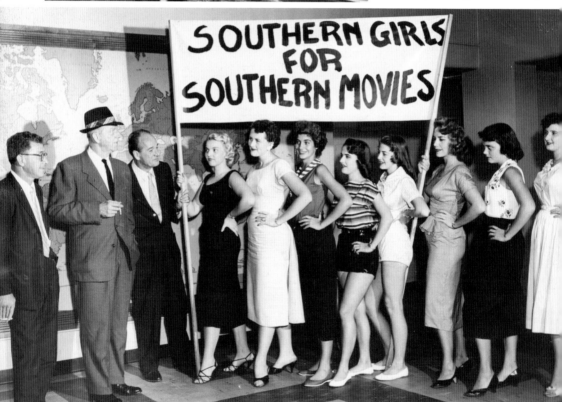

Erskine Caldwell
Caldwell, who grew up in Wrens, Georgia, saw his first published writing in the *Jefferson Reporter* in Wrens. He also was a sports news correspondent for the *Augusta Chronicle*. His lifetime work of more than 60 published titles, beginning with *The Bastard* in 1929, included *Tobacco Road* and *God's Little Acre*. His father, Rev. Ira S. Caldwell, also a writer for the *Chronicle*, is buried in Wrens. He is shown here wearing a hat at left during a mock protest staged for *God's Little Acre*. (Photograph by Morgan Fitz; courtesy Fitz-Symms Studio.)

Janelle Taylor

More than 24 million copies have been sold of Taylor's 35-plus lusty historical romance novels. She has made the *New York Times* best-seller lists seven times with hunky, bare-chested supermodel Fabio posing for many of her novels' cover paintings. Taylor's books have been translated into languages of more than 25 countries. Her first book, *Savage Ecstasy*, was published in 1981. (Photograph by Rudy Nyhoff; courtesy the *Augusta Chronicle*.)

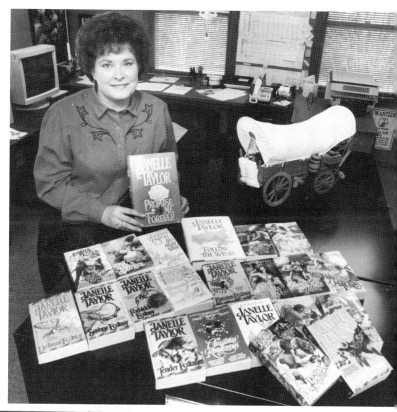

Louise Shivers

Shivers's novel *Here To Get My Baby Out of Jail* was turned into the movie *Summer Heat*, costarring Lori Singer, Anthony Edwards (before the television hit show *ER*), Bruce Abbott, Kathy Bates, and Clu Gulager. The world premiere was held in the Imperial Theatre in 1987. Shivers, who sold shoes and records in the Sears store on Walton Way, also became writer-in-residence at Augusta State University. (Photograph by Herb Welch; courtesy the *Augusta Chronicle*.)

Reginald Wells
This native of England was a founding editor for *Sports Illustrated* magazine, a filmmaker for the *March of Time* newsreels, director of public relations for Scott Paper Company, and director of corporate communications for Morris Communications Company. He directed and produced the official films of the Masters Tournament for the Augusta National Golf Club for 21 years (1961–1982). Here, wearing the white hat, he and his crew cover the Augusta Futurity. (Courtesy Morris Communications Company.)

Dr. Robert Greenblatt
This internationally known endocrinologist and pioneer of the oral contraceptive pill authored or edited more than 20 books, making complex medical subjects understandable to the average audience. His book, *Search the Scriptures: Modern Medicine and Biblical Personages*, went through 26 printings. The library on the Georgia Regents University (formerly MCG) campus is named for him. Wells is seen here with his son Edward and daughter Deborah Karpas. (Photograph by James M. Caiella; courtesy the *Augusta Chronicle*.)

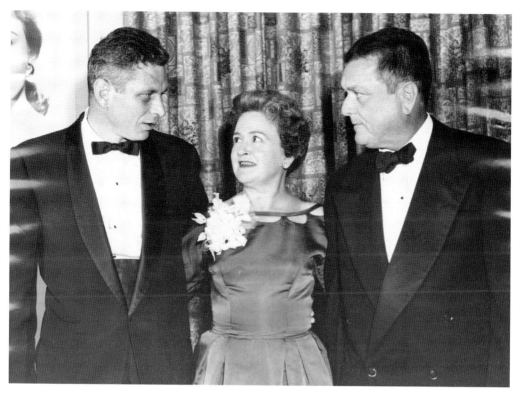

Dr. Corbett H. Thigpen and Dr. Hervey M. Cleckley
Augusta psychiatrists Dr. Corbett H. Thigpen and Dr. Hervey M. Cleckley based their book *Three Faces of Eve* on the real story of their patient from Edgefield, South Carolina, Chris Costner Sizemore, who had multiple personalities. The movie based on the book earned an Oscar for native-Georgian Joanne Woodward, whose father, Wade Woodward Jr., was a native Augustan. Woodward's mother, Elinor, is shown between Thigpen, on the left, and Cleckley. (Photograph by Morgan Fitz; courtesy Fitz-Symms Studio.)

Morgan Fitz
Fitz, being thanked by three-year-old Caren Dorn for taking her photograph during the 1961 Masters Parade, was one of Augusta's best-known photographers. He started his photography business in Augusta in 1945 and joined Robert Symms in creating the Fitz-Symms Company in 1949. The company had the contract to take photographs for the *Augusta Chronicle* and *Augusta Herald* for 10 years. His wife, Jean Fitz, was a well-known Augusta author. (Courtesy the *Augusta Chronicle*.)

99

Berry Fleming
Fleming authored about 20 books, mostly novels, beginning with his 1927 adventure story *The Conqueror's Stone*. His best-known novel, *Colonel Effingham's Raid*, based on Augusta's Cracker Party political organization, was published in 1943. It was made into a 20th Century Fox movie of the same name, starring Savannah-born actor Charles Coburn. Fleming died at age 90 in 1989. (Photograph by Blake Madden; courtesy the *Augusta Chronicle*.)

Frank Yerby
On the edge of the Paine College campus is the restored remains of the two-story house in which Frank Yerby once lived. Yerby was born in Augusta in 1916 to a Scottish-Irish mother and African American father. He graduated from Paine College and went on to become the first, best-selling African American author with *The Foxes of Harrow* in 1946. His 33 novels have sold more than 55 million copies. (Photograph by Jonathan Ernst; courtesy the *Augusta Chronicle*.)

CHAPTER SEVEN

Educators and Religious Leaders

Religion and public education have been major parts of the lives of Georgians almost since the settlement of Savannah by British general James Edward Oglethorpe in 1733.

John and Charles Wesley, cofounders of the Methodist movement, arrived in Savannah in 1736, and, although their stays were brief, their work is remembered by a statue of John in downtown Savannah and a historical marker on Cockspur Island near Fort Pulaski.

John Wesley taught a Sunday school program for children (reputedly the first in America) and in 1737 published a *Collection of Psalms and Hymns*, the first English hymnal in America. The hymnal was printed in 1737 in Charleston, South Carolina, by Lewis Timothy.

Augusta's religious culture dates at least to 1750, when the Church of England established Saint Paul's Episcopal Church on Reynolds Street at Sixth Street at the site of Fort Augusta. The current building is the fifth Saint Paul's building, according to the church, and was built following the 1916 fire, which destroyed many downtown structures and residences.

The oldest church building in Augusta dates to 1801 and can be found on Reynolds Street near Twelfth Street. It originally was constructed by Augusta's first Methodist society and was located in the 700 block of Greene Street. It was sold in 1844 to Springfield Baptist Church, one of the earliest independent black congregations in the United States, and moved from Greene to its present location.

Atlanta's Morehouse College was started in the basement of Springfield Baptist in 1867, and the Georgia Equal Rights Association, which evolved into the Georgia Republican Party, was founded in Springfield in 1866.

Other significant religious connections to Augusta include Rev. Billy Graham holding his first ecumenical crusade in the city's Bell Auditorium in 1948; the pastor and founder of Tabernacle Baptist (Rev. Charles T. Walker) creating the first black YMCA in New York City; the fathers of US president Woodrow Wilson and US Supreme Court judge Joseph R. Lamar preaching in Augusta at the same time; and a pew in Reid Memorial Presbyterian Church that has a plaque on its side commemorating where US president Dwight D. Eisenhower and his wife, Mamie, usually sat during their many visits to the city.

Public education in Augusta notably includes the Academy of Richmond County becoming an all-boys school in 1783. The academy, now coeducational, was visited by US president George Washington in 1791 when it was located on the Savannah River near Bay and Fourth Streets in the former home of Belgium-born Emanuel Wambersie. It is regarded as the oldest public school in the South and one of the five oldest public schools in the nation.

Public school teachers and principals always have had a significant impact on the Augusta community with many of them serving on local government boards and becoming true local legends.

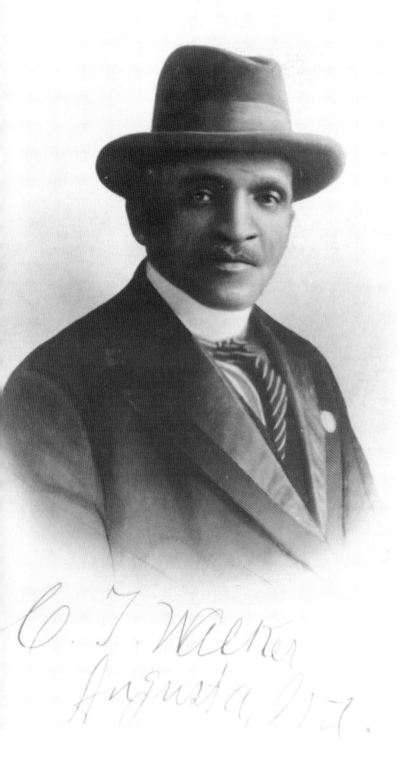

Rev. Charles T. Walker
The Rev. Charles T. Walker became one of the nation's best-known evangelists. He served as chaplain of the "Tan Yanks," black American soldiers who fought with Teddy Roosevelt in Cuba. He was one of the first black ministers to travel to the Holy Land and write about it. Both US president Howard Taft and millionaire John D. Rockefeller came to Tabernacle Baptist Church after Walker founded it in Augusta. Laney-Walker Boulevard in front of the church was named after Walker and Lucy C. Laney. He also created the first black YMCA in New York City. More than 10,000 people, white and black, filed past his casket when he died. (Courtesy the *Augusta Chronicle*.)

Lucy Craft Laney

Laney, born in Macon, Georgia, in 1854, started the first school in Augusta for black boys and girls. It opened in 1883 in the basement of the Christ Presbyterian Church, then at Tenth and Telfair Streets, with six students. The school's first class graduated in 1885. Her school, Haines Normal and Industrial Institute, was renamed after her death in 1933, becoming the Lucy Craft Laney Comprehensive High School in her honor. She also started the first black kindergarten in Augusta and the first black nursing school in the city, the Lamar School of Nursing. Her influence and accomplishments were such that then-Georgia governor Jimmy Carter in 1974 commissioned a portrait of her, which was hung and unveiled in the Georgia State Capitol. In 1983, Laney was inducted into the Georgia Women of Achievement Hall of Fame. (Courtesy the *Augusta Chronicle*.)

Dr. George Stoney
Dr. Stoney (front, center) was a prominent physician responsible in 1939 for setting up Lamar Hospital, which housed students of the Lamar School of Nursing, founded by Lucy Craft Laney and Dr. William H. Doughty as one of the first nursing schools for African Americans in the South. Dr. Stoney also helped bring about the Lenox Theater, a nice theater for black audiences in Augusta. (Courtesy the Augusta Museum of History.)

Rabbi Norman Goldburg
Rabbi Goldburg and his family came to Augusta in 1949 when the Congregation Children of Israel Temple was on Telfair Street. He retired in 1968, becoming rabbi emeritus of the Walton Way Temple and remained Fort Gordon's Jewish chaplain until 1987. He was known for administering to hospital patients of all religious faiths. He also taught philosophy and ethics at Augusta College (now GRU Summerville) for 12 years. Goldburg was the author of several books including *Patrick J. McGillicuddy and the Rabbi*, which looked at humorous situations and behind-the-scenes problems of the ministry. (Photograph by Drake White, courtesy the *Augusta Chronicle*.)

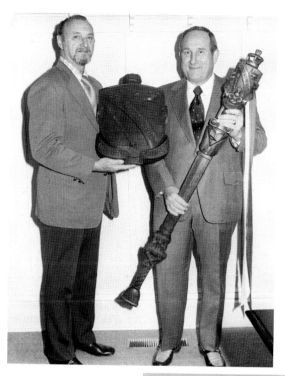

George A. Christenberry

Christenberry, who died in 2009 at age 93, became the sixth president of Augusta State College, now Georgia Regents University, Summerville, in 1970. He retired as president in 1986. He served for about a year as acting vice chancellor for the University System of Georgia. He was active with First Baptist Church of Augusta and many civic groups, including the Human Relations Commission, Greater Augusta Arts Council, Augusta Richmond County Museum and the Augusta Genealogical Society. He is shown at right in 1974 with Nathan Bindler. (Photograph by Nelson Harris; courtesy the *Augusta Chronicle*.)

C.S. Hamilton

Besides being the pastor of Tabernacle Baptist Church for 40 years, Hamilton also was one of Augusta's pioneer black city council members. He is shown at right qualifying to run for office along with Augusta's first black councilman, B.L. Dent. Harrison Street, adjacent to the tabernacle, was renamed C.S. Hamilton Way in his honor in 2010. He died in 1997 at age 70. (Photograph by George Schaeffer; courtesy the *Augusta Chronicle*.)

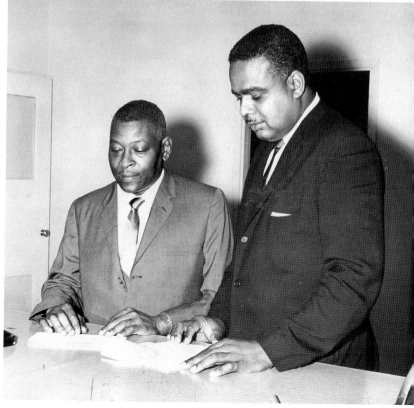

Fr. Dan Munn

The Very Reverend Father Daniel M. Munn, founding pastor of St. Ignatius of Antioch Melkite-Greek Catholic Church in Augusta, was director of pastoral care at St. Joseph Hospital (now Trinity Hospital) from 1984 until 2000. He held several posts at the Medical College of Georgia, including chaplain, pastoral consultant in family medicine, and director of MCG's program in human sexuality. He also was a well-known local actor, named Best Actor by the Augusta Players in 1980. (Photograph by Margaret Sellers; courtesy the *Augusta Chronicle*.)

Christine Miller-Betts

Georgia governor Nathan Deal appointed Miller-Betts to the Martin Luther King Jr. Advisory Council. For many years, she has been executive director of the Lucy Craft Museum of Black History in Augusta. She also has served on the board of trustees of Historic Augusta and the Southeastern Museum Association. She has been president of the Augusta Women's Civic Club and a lifetime member of the NAACP. (Photograph by Rainier Ehrhardt; courtesy the *Augusta Chronicle*.)

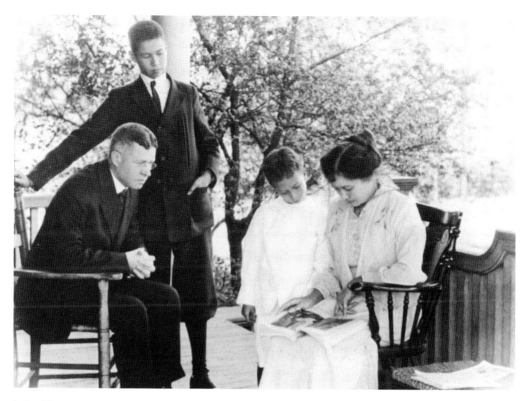

John Hope
Hope (seated) was born in 1868 in Augusta to a Scottish-born father, James Hope, and a free African American woman, Mary Frances Butts, who was born in Hancock County, Georgia. In 1906, Hope became the first black president of Atlanta's Morehouse College—the alma mater of Martin Luther King Jr.—and in 1929 became the first African American president of Atlanta University (later Clark Atlanta University). (Courtesy the *Augusta Chronicle*.)

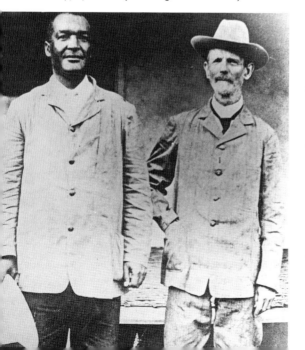

John Wesley Gilbert
The Gilbert-Lambuth Chapel at Augusta's Paine College was conamed for John Wesley Gilbert, Paine's first student, first graduate, and first black member of the Paine faculty, and Bishop Walter Russell Lambuth, a physician and theologian. Gilbert, was born to slaves in Hephzibah, Georgia. While at Brown University, he earned a scholarship to study Greek excavations. He returned to Augusta in 1891 to teach Greek and English at his former college. He died in 1923. Gilbert is shown at left with Bishop Lambuth. (Courtesy the *Augusta Chronicle*.)

Rev. C.W. Edwards Jr.
Edwards, a longtime pastor of Mize Memorial Methodist Church and a decorated World War II hero, was an original member of the Augusta-Richmond County Coliseum Authority that built what is now James Brown Arena. He became chairman of the authority and was also a charter member and treasurer of the Augusta-Richmond County Convention and Visitors Bureau. He was president and chaplain of the Augusta Lions Club and a district governor of Lions International. (Courtesy the *Augusta Chronicle*.)

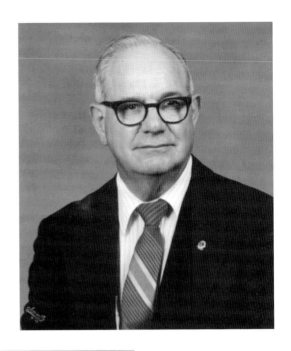

Beverly Barnhart
In 2008, Barnhart was honored in Atlanta with the first Woodruff Arts Center Lifetime Achievement Award for cofounding Richmond County's magnet school program in the late 1970s. She helped establish C.T. Walker Traditional Magnet, A.R. Johnson Health Science and Engineering Magnet, and John S. Davidson Fine Arts Magnet, and served as Davidson's first principal for 19 years. Davidson, under Barnhart's leadership, was nationally recognized as being a template for what a good public arts/academic school should be. (Photograph by Judy Ondrey; courtesy the *Augusta Chronicle*.)

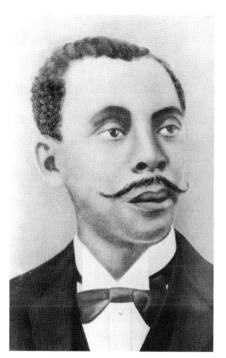

Augustus Roberson Johnson
Born in 1854, Johnson became the first black teacher licensed by the state of Georgia and paid with state funds. He started teaching at 16 and taught for 40 years. He died in 1908. The Mauge Street Grammar School opened in 1892 and took the name A.R. Johnson Junior High School in 1937. It became A.R. Johnson Health Science and Engineering Magnet School. (Courtesy the *Augusta Chronicle*.)

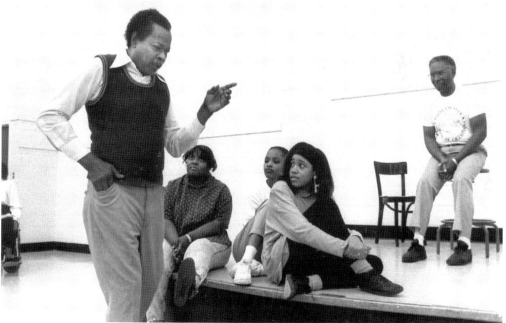

James "J.C." Taylor
Taylor was the director of drama and taught English and speech courses at Paine College from 1956 to 1999. He was also on the historical ministry of Tabernacle Baptist Church. He directed many plays performed in the Odeum classroom of Gilbert-Lambuth Chapel. This rehearsal in 1991 shows, from left to right, Taylor, Sharon Parker, Jacqulyne Ephran, Natasha Watkins, and Leslie Stokes. (Photograph by Eric Olig; courtesy of the *Augusta Chronicle*.)

Edward J. Cashin Jr. Cashin Jr., who died in 2007, was one of Augusta's best-known historians. He became chairman of the history department at Augusta College (now GRU Summerville) in 1975 and retired from Augusta State University in 1996 as professor emeritus. He then founded and became director of the Center for the Study of Georgia History at Augusta State University. His several books include *The Story of Augusta* (1980). (Photograph by Jim Blaylock; courtesy the *Augusta Chronicle*.)

Dr. William H. Moretz Moretz died in 1989 at the Medical College of Georgia (MCG) Hospital, of which he had supervised been serving as president. He joined MCG as a professor and chairman of the department of surgery. MCG graduates almost doubled during his tenure, and more than $25 million in new construction and renovations were completed. He was also president of the Southeastern Surgical Society. (Photograph by Rogers Photography; courtesy the *Augusta Chronicle*.)

Ike and Justine Washington
Ike became principal of the huge Lucy Laney High School and was a popular Augusta City councilman. Justine, who taught in rural area schools, became one of the first black citizens to serve on the Richmond County Board of Education. Washington Hall at Augusta State (now GRU Summerville) is named for the couple, who also were the executors of actress Butterfly McQueen's will. (Photograph by Randy Hill; courtesy the *Augusta Chronicle*.)

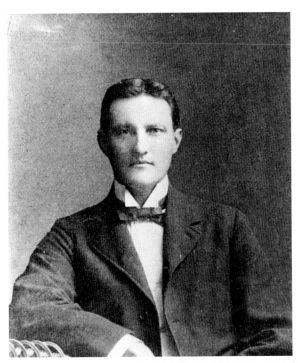

Lawton B. Evans
Evans, the first Augusta Author's Club president, served as Richmond County schools superintendent from 1882 until his death in 1934. He guided the consolidation of all Richmond County schools into a single system. He wrote a series of books for young people and textbooks about Georgia history that were used by both grade school and high school students until 1938. (Courtesy the *Augusta Chronicle*.)

Clemens de Baillou
When de Baillou died in Wiesbaden, Germany, in 1978, it made news in Augusta because he had been director of both the Augusta-Richmond County Museum and the Gertrude Herbert Memorial Art Institute from 1964 until his retirement in 1977. The baron and knight of the Order of Malta had previously worked for the University of Georgia and the Georgia Historical Commission. (Courtesy the *Augusta Chronicle*.)

CHAPTER EIGHT

At Your Command

Augusta is a city that has always honored its military heroes with historical markers and monuments, annual ceremonies, patriotic and veterans' organizations, and the naming of parks, forts, streets, bridges, and other structures.

Dyess Parkway and Dyess Park are both named for Aquilla James "Jimmie" Dyess, who is the only American to receive both the Carnegie Medal for civilian heroism and the Medal of Honor.

The Confederate Monument in the 700 block of Broad Street has statues of four generals around its base, but it was local resident and Confederate private Berry Benson who was the model for the statue on the monument's top.

There are many other markers and monuments in and around the city (especially on Greene Street and lower Broad Street) with the names of soldiers who fought in conflicts and wars and paid with their lives.

Butt Memorial Bridge on Fifteenth Street, which spans the Augusta Canal, is said to be the only bridge in the world named for a victim of the 1912 *Titanic* disaster. It honors former Augustan and US Army major Archibald Butt, who was the military aide to two presidents.

Augusta has had soldiers from the Revolutionary War, the Civil War, the Spanish-American War, World War I, World War II, the Korean War, Vietnam War, and just about every other military engagement involving the United States.

Five-star army general Henry "Hap" Arnold flew biplanes in Augusta when he was stationed at the Wright brothers' Signal Corps Aviation School off Sand Bar Ferry Road during the winter of 1911–1912.

Augusta owes its existence to British general James Edward Oglethorpe, who initiated the building of Fort Augusta in 1735 to protect fur traders and to further establish business relations with local Native Americans. A historical marker in the shape of a Celtic cross signifies the former site of the fort on the grounds of Saint Paul's Episcopal Church at the levee near Sixth Street, and there is a statue of Oglethorpe on the Augusta Common in the 800 block of Broad Street.

Archibald Butt
The Fifteenth Street bridge over the Augusta Canal is unique in that it is considered the only bridge in the world named for a victim of the *Titanic* sinking in 1912. Maj. Archibald Butt, an Augusta native, was the military aide to US presidents Theodore Roosevelt and William Howard Taft. Butt had a glorious career as a journalist reporting for Kentucky's *Louisville Courier-Journal* and Georgia's *Macon Telegraph* for a year before moving to Washington, DC, and covering national affairs for several Southern newspapers, including his hometown daily *Augusta Chronicle*. He was visiting Europe with his close friend, painter Francis Millet, when they boarded the *Titanic* and sealed their fates. There is a fountain near the White House that honors Butt and Millet, and there is a cenotaph at Arlington National Cemetery that also honors Butt. (Bridge photograph by Michael Holahan; both, courtesy the *Augusta Chronicle*.)

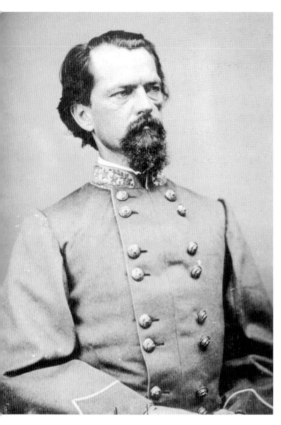

John B. Gordon
The namesake of Camp Gordon, which became Fort Gordon, was a Confederate general who became a US senator from 1873 to 1880 and again from 1891 to 1897. He also served as the 53rd governor of Georgia from 1886 to 1890. Fort Gordon was established as a US Army base in 1917. It is the current home of the United States Army Signal Corps. (Courtesy the *Augusta Chronicle*.)

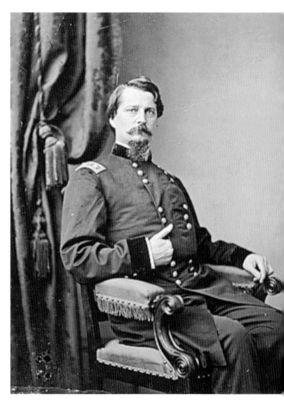

Winfield Scott Hancock
Camp Hancock, which existed during World War I in the area of what is now Daniel Village shopping center on Wrightsboro Road, was named in 1917 after the US Army major general who presided over the executions of the Lincoln assassination conspirators. He was from Pennsylvania, and the Pennsylvania Guard was to come to Camp Hancock. It had more than 1,300 temporary buildings and, at its peak, 35,148 troops in October 1918. (Courtesy the *Augusta Chronicle*.)

Alfred Cumming

Who would have thought it was a native Augustan that US president James Buchanan selected to oust Mormon leader Brigham Young in 1858 as governor of the territory of Utah? Buchanan sent the former Augusta mayor to Salt Lake City with a military force of 2,500 troops. Cumming served until 1861. He eventually returned to Augusta, where he died in 1873. He is buried in Summerville Cemetery. (Photograph by Don Rhodes.)

Ambrose Gordon

This former Revolutionary War officer was appointed head of the delegation welcoming US president George Washington to Augusta in 1791, when the city was the capital of Georgia. Gordon's son was the first Georgian to graduate from West Point and the founder of the Georgia Railroad. His great-granddaughter was Juliette Gordon Low, founder of the Girl Guides of the USA, which became the Girl Scouts of America. (Photograph by Don Rhodes.)

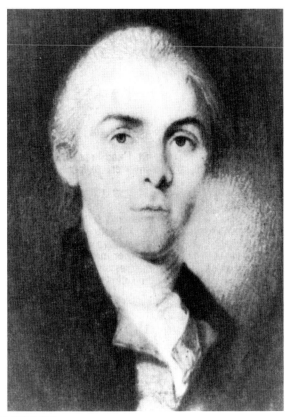

Robert Forsyth
Forsyth, one of the first 13 US marshals appointed by US president George Washington, became the first federal law enforcement officer killed in the line of duty. Forsyth was shot and killed on January 11, 1794, by Beverly Allen while attempting to serve civil court papers. Allen was arrested and escaped twice; he, by all accounts, got away with murder. Forsyth's son John became governor of Georgia and the US minister to Spain. (Courtesy the *Augusta Chronicle*.)

John Forsyth
John Forsyth had an outstanding political career. He became a lawyer in 1802 and that same year married Clara Meigs, daughter of Josiah Meigs, the first president of the University of Georgia. He became attorney general of Georgia, served in both the US House of Representatives and US Senate, became US minister to Spain, was twice elected as Georgia governor, and became the US secretary of state. Forsyth Park in Savannah and Forsyth, Georgia, are named after him. (Courtesy the *Augusta Chronicle*.)

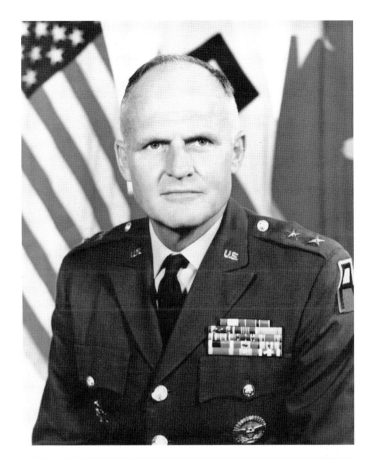

John C.F. Tillson III
This major general commanded Fort Gordon from 1968 to 1971. He died in 2001 at age 86. The veteran of World War II and Vietnam was born in Fort Huachuca, Arizona, and graduated from West Point in 1938. He made the US modern pentathlon team for the 1940 Olympics, but the games were canceled due to the outbreak of World War II. (Courtesy the *Augusta Chronicle*.)

George Steptoe Washington
Washington, a former captain of the 8th Virginia Infantry and nephew of US president George Washington, died in Augusta in 1809 at age 37. He was buried, at his request, in Saint Paul's Episcopal Churchyard next to his friend Ambrose Gordon. His widow, Lucy, remarried US Supreme Court justice Thomas Todd. Their wedding was the first in the White House since Lucy's sister, Dolley Madison, had become first lady. (Photograph by Don Rhodes.)

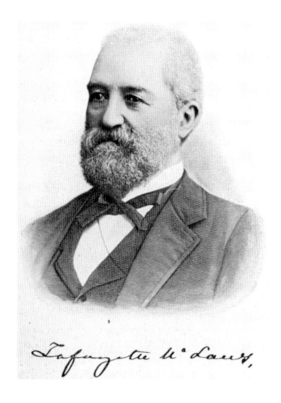

Lafayette McLaws
The papers of native-Augustan Lafayette McLaws at the University of North Carolina at Chapel Hill include items related to the US Army campaigns against the Navajos, the Civil War campaigns in which McLaws participated, including Gettysburg, and McLaws's court martial in 1864 for failure to cooperate with Gen. James Longstreet and his exoneration. McLaws worked in the insurance business after the Civil War and was a tax collector for the IRS and Savannah's postmaster. There is a statue of McLaws in Savannah's Forsyth Park. (Courtesy the *Augusta Chronicle*.)

James Longstreet
One of the foremost Confederate generals of the Civil War was born just across the Savannah River from Augusta. He went as a youth to live in Augusta with his uncle Augustus Baldwin Longstreet, who was a newspaper editor, educator, and Methodist minister. Longstreet spent eight years on his uncle's plantation and attended the Academy of Richmond County. His successful postwar career was spent working for the US government as a diplomat, civil servant, and administrator. (Courtesy the *Augusta Chronicle*.)

Raymond O. Barton

Barton, shown at center with Henry S. Matthews (left) and Jack Juback, was commander of the 4th Infantry division during World War II. He led his 20,000 men and 1,700 vehicles into battle at Utah Beach on D-Day. The troops broke through German lines to meet with members of the 82nd Airborne Division at St. Mere Eglise. The namesake of Fort Gordon's Barton Field went on to lead the 4th Division through France, the assault on the Siegfried line of Germany, and the Battle of the Bulge. (Photograph by Vernon Gould; courtesy the *Augusta Chronicle*.)

Aquilla James "Jimmie" Dyess

Dyess, who is honored with this large exhibit at the Augusta Museum of History, grew up in Augusta and North Augusta. He is the only American to receive both the Carnegie Medal for civilian heroism (he saved two swimmers) and the Medal of Honor for military heroism. The lieutenant colonel was killed during World War II by enemy machine-gun fire. His son-in-law is retired Air Force major general Perry Smith, a military commentator for CNN and other national broadcasts. Dyess Parkway and Dyess Park in Augusta are named for him. (Photograph by Andrew Davis Tucker; courtesy the *Augusta Chronicle*.)

Dwight David and Mamie Eisenhower
As a retired five-star general, Eisenhower and his wife, Mamie, first visited the Augusta National Golf Club in April 1948 for nearly two weeks at the urging of Masters Tournament chairman Clifford Roberts and club member William Robinson. He continued to visit Augusta after serving as supreme commander of the Allied Forces in World War II. In all, he made 45 trips to Augusta: 5 before he became president, 29 while president, and 11 after his last term. He commonly stayed on the grounds of the golf club, and he and Mamie were frequent visitors at Reid Memorial Presbyterian Church on Walton Way, attending services at least 18 times; a metal plaque designates the Eisenhowers' favorite pew. He also helped lay the cornerstone for the church's new sanctuary. Above, Eisenhower (right) and Brig. Gen. Howard M. Hobson prepare to inspect Fort Gordon troops on January 7, 1961. Below, Mamie (right) greets Ike on his November 13, 1959, arrival. The flowers were for Mamie's birthday. On the opposite page, President Eisenhower disembarks from his plane in Augusta. (Above, photograph by Morgan Fitz; courtesy the *Augusta Chronicle*; below and opposite page, photographs by Robert Symms, courtesy the *Augusta Chronicle*.)

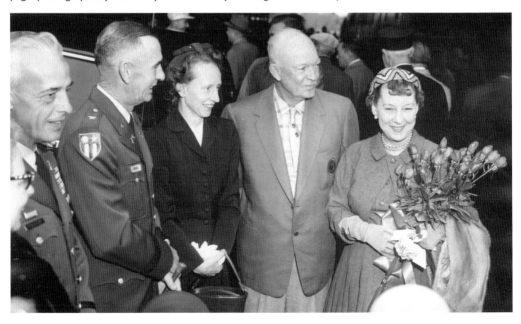

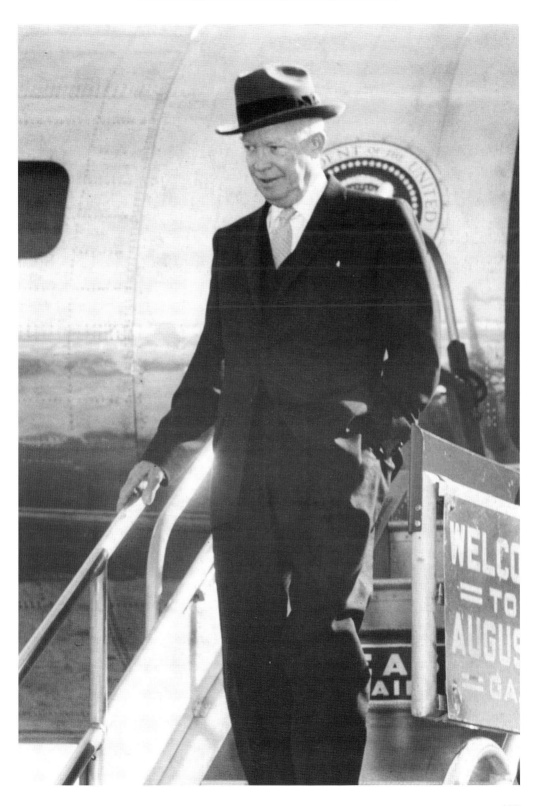

Edward Porter Alexander
Alexander, who is buried in Augusta's Magnolia Cemetery, was one of only three Confederate officers during the Civil War to rise to the rank of general in the artillery branch. He taught mathematics after the war at the University of South Carolina in Columbia and was executive superintendent of the Augusta Railroad. He died in 1910 in Savannah but was buried in Augusta next to his wife, Betty, who had died in Augusta in 1899. (Courtesy the *Augusta Chronicle*.)

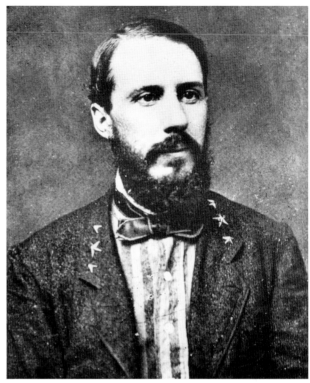

Beverly Brown Funderburg
Massachusetts-born Funderburg, who made North Augusta, South Carolina, her home for 60 years, was one of the first women beginning in 1943 to serve with the US Coast Guard during World War II. She was a charter member of Immanuel Baptist Church and a member of the Jesse C. Lynch Memorial American Legion Post 71 in North Augusta. She retired from the Veterans Administration with 24 years of service and volunteered at the Charlie Norwood Veterans Administration Hospital in Augusta. (Photograph by Crystal Garcia; courtesy the *Augusta Chronicle*.)

Berry Benson on Confederate Monument
This former Confederate private was the model for the statue
on top of the Confederate Monument in downtown Augusta.
He was captured as a prisoner twice during the war and escaped
twice. He wrote about his war accounts. He lived quietly after
the war as an accountant in North Augusta, South Carolina, and
invented a fail-safe method for checking and correcting even the
most complex accounts. He sold this "Zero System" nationally. He
and his wife wrote poetry for publication. The house in which he
died on January 1, 1923, is now a physicians office; it faces West
Avenue in North Augusta. Benson remained active in his later
years, and at the age of 79 he led Boy Scouts on 15-mile hikes
in the woods. His daughter Pauline was a librarian at the North
Augusta Library. In 1962, his daughter-in-law Susan Williams Benson
published portions of his war journal, titled *Berry Benson's Civil War
Book*. (Courtesy the *Augusta Chronicle*.)

INDEX